Raw Color The Circles of David Smith

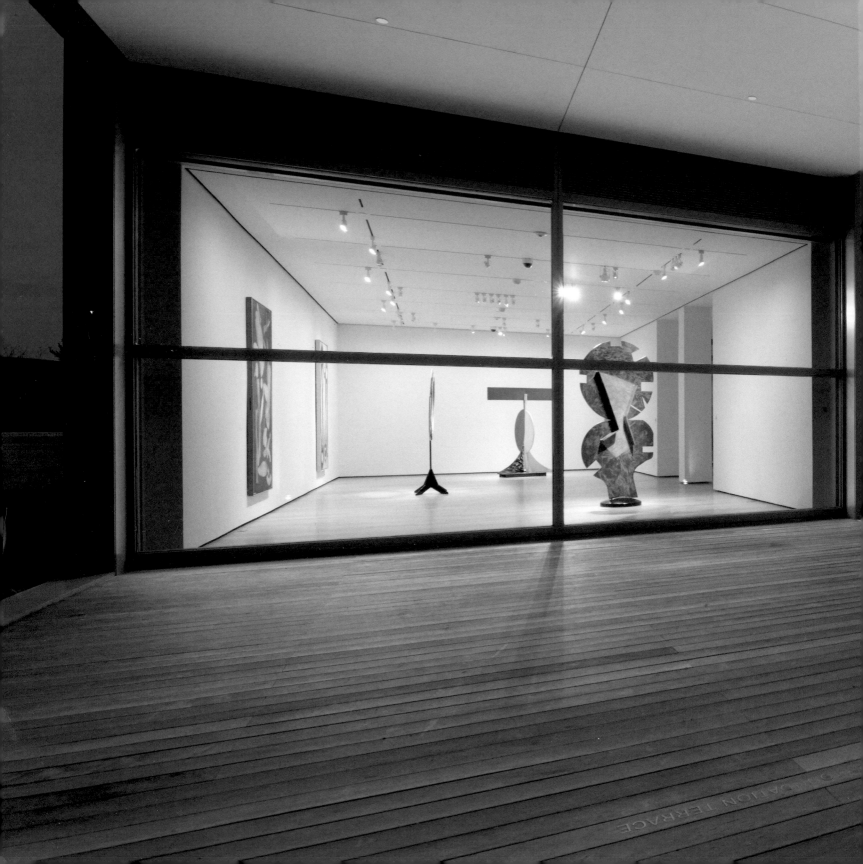

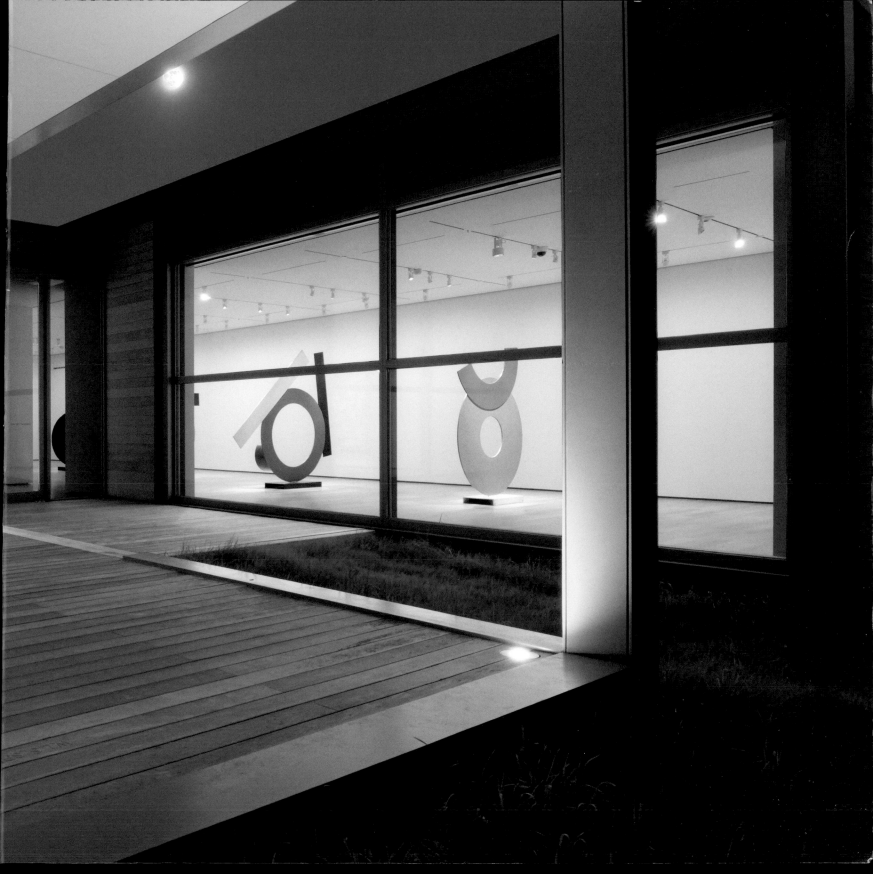

Raw Color The Circles of David Smith

Edited by David Breslin
With essays by Michael Brenson, David Breslin,
and Charles Ray

Clark Art Institute
Williamstown, Massachusetts

Distributed by Yale University Press
New Haven and London

Published on the occasion of the exhibition *Raw Color: The Circles of David Smith*,
Clark Art Institute, Williamstown, Massachusetts
July 4, 2014, to October 19, 2014

Produced by the Publications Department of the Clark Art Institute,
225 South Street, Williamstown, Massachusetts 01267
clarkart.edu

Raw Color: The Circles of David Smith has been published with support from
Furthermore: a program of the J.M. Kaplan Fund

Furthermore:
a program of the J.M. Kaplan Fund

Thomas J. Loughman, *Associate Director of Program and Planning*
Anne Roecklein, *Managing Editor*
Michael Agee, *Photographer*
Dan Cohen, *Special Projects Editor*
Hannah Rose Van Wely, *Publications Assistant*

Produced by Vern Associates Inc., Amesbury, Massachusetts
www.vernassoc.com
Edited by Brian Hotchkiss
Designed by Peter M. Blaiwas
Production by Susan McNally
Printed and bound by Kirkwood Printing, Wilmington, Massachusetts

Distributed by Yale University Press, 302 Temple Street,
P.O. Box 209040, New Haven, Connecticut 06520-9040
yalebooks.com/art

Printed and bound in the United States of America
10 9 8 7 6 5 4 3 2 1

Library of Congress Cataloging-in-Publication Data

Raw color : the Circles of David Smith / edited by David Breslin ; with essays by
Michael Brenson, David Breslin, and Charles Ray.
 pages cm
 "Published on the occasion of the exhibition *Raw Color: The Circles of David Smith,*
Clark Art Institute, Williamstown, Massachusetts, July 4, 2014, to October 19,
2014."
 ISBN 978-1-935998-16-7 (Sterling and Francine Clark Art Institute (publisher) : alk.
paper) — ISBN 978-0-300-20791-0 (Yale University Press (distributor) : alk. paper)
1. Smith, David, 1906–1965. Circles—Exhibitions. 2. Steel sculpture, American—
Exhibitions. I. Breslin, David, editor. II. Brenson, Michael. First of forms. III. Breslin,
David. Smith's toe, Descartes's doubt. IV. Ray, Charles, 1953– There is no color in
the great outdoors. V. Sterling and Francine Clark Art Institute.

 NB237.S567A4 2014
 730.92—dc23

 2014017507

Cover illustrations: *Raw Color* exhibition in the galleries of the Lunder Center at
Stone Hill, Clark Art Institute, Williamstown, Massachusetts, 2014

Contents

Director's Foreword

Michael Conforti

When I look at photographs of David Smith's home and studio in Bolton Landing, New York, I am awestruck by the similarities between that special place in the Adirondacks and the Clark's idyllic position in the Berkshires. Smith's studio and the Clark's Tadao Ando–designed Lunder Center at Stone Hill are located less than one hundred miles from each other. At each place, the buildings themselves are no more important than the trees that surround them, the sky and clouds that give cover, and the hills that ground it all. They are all of a piece. It is fitting that the Clark is showing works by David Smith during the opening season of our expanded campus. Smith's practice shows us a way forward as the Clark renews its commitment to fostering an engaged relationship between art and nature.

Curated by David Breslin, the Clark's associate director of the Research and Academic Program and associate curator of contemporary projects, *Raw Color: The Circles of David Smith* addresses the relationships among landscape, industry, and the works Smith produced from 1961 to 1963. In his *Circle Series,* the heart of this exhibition, color plays a crucial role. Much to the consternation of his otherwise fervent supporter Clement Greenberg, Smith frequently painted his sculptures and at this time did so with greater intensity. During this period, when his chromatic choices—including acid green and emergency orange—separated his work from organic references, he increasingly populated his fields in Bolton Landing, near Lake George, with sculpture. Painted in colors contrary to those found in nature, but constructed to stand in concert with the dramatic Adirondack landscape that was so important to him, Smith's sculptures confront viewers with a conflict: How are we to be modern, responsive to the materials and technologies of our time, and also remain conscious of nature and our respective

locales? Smith signaled his preoccupation with polychromatic sculptures and spray paintings in a 1964 interview with the poet and curator Frank O'Hara. He expressed his preference for "raw colors." The Clark's exhibition concentrates on those works indebted to color, which tend to receive less attention and study than his better-known works in unpainted steel.

This exhibition would have been impossible had it not been for the unwavering and generous collaboration of the Estate of David Smith. Peter Stevens, executive director, has been instrumental in ensuring its success. His careful and expert stewardship of this important legacy is admirable. I am deeply grateful for Rebecca Smith's enthusiasm and support of this exhibition of her father's work. It was marvelous to hear from her how much Williamstown's Stone Hill reminded her of her childhood summer home in the Adirondacks. I thank her for her time and insights. I extend my thanks to Candida Smith for contributing so much to the scholarship on David Smith. It is difficult to imagine this exhibition at the Clark were it not for her important essay "The Fields of David Smith," which Charles Ray cites in his essay included here.

My sincere gratitude goes to the authors who have contributed so ingeniously to this catalogue. The essay by scholar and critic Michael Brenson is a brilliant personal, historical, and theoretical reflection on the centrality of the circle to Smith's practice and offers an important account of a chapter that has been overlooked. Ray, one of the foremost artists working in sculpture today, adds a penetrating meditation on the relationships among objects, color, and landscape. Breslin's essay on Smith's spray paintings offers a novel take on the artist's working methods.

In addition, I would like to extend my deepest thanks to the lenders to this exhibition. With the Estate of David Smith, the National Gallery of Art, Washington, has provided the core of this exhibition. It is thrilling to have these important sculptures at the Clark at the same time as we present *Make It New: Abstract Painting from the National Gallery of Art, 1950–1975*, one of the inaugural exhibitions of the new Clark Center. I am extremely grateful to the Albright-Knox Art Gallery; Lisa Erf, director and curator of the JPMorgan Chase Art Collection; and Gagosian Gallery for their key loans. My thanks are also extended to Susan J. Cooke, Allyn Shepard, and Tracee Ng at the Estate of David Smith for their diligent and careful work, and I am grateful to Joan Davidson and the J. M. Kaplan Fund's Furthermore program for supporting the publication of this catalogue.

In a 1955 address he gave at the University of Mississippi, Smith delivered one of his typically astute and bracing statements: "Nature, after all, is everything and everybody. It is impossible for any artist not to be of nature or to deal with problems other than those of nature."[1] This beautiful exhibition at the Clark, in the Berkshires, allows us to witness how this artist grappled with that eternal problem. My most profound thanks, therefore, are reserved for David Smith, whose struggles with and compassion toward material, nature, and his times have left an indelible mark on this world.

Note

1 David Smith, "The Artist and Nature," address given at the University of Mississippi on March 8, 1955. In Jörn Merkert, ed., *David Smith: Sculpture and Drawings* (Munich: Prestel-Verlag, 1986), p. 152.

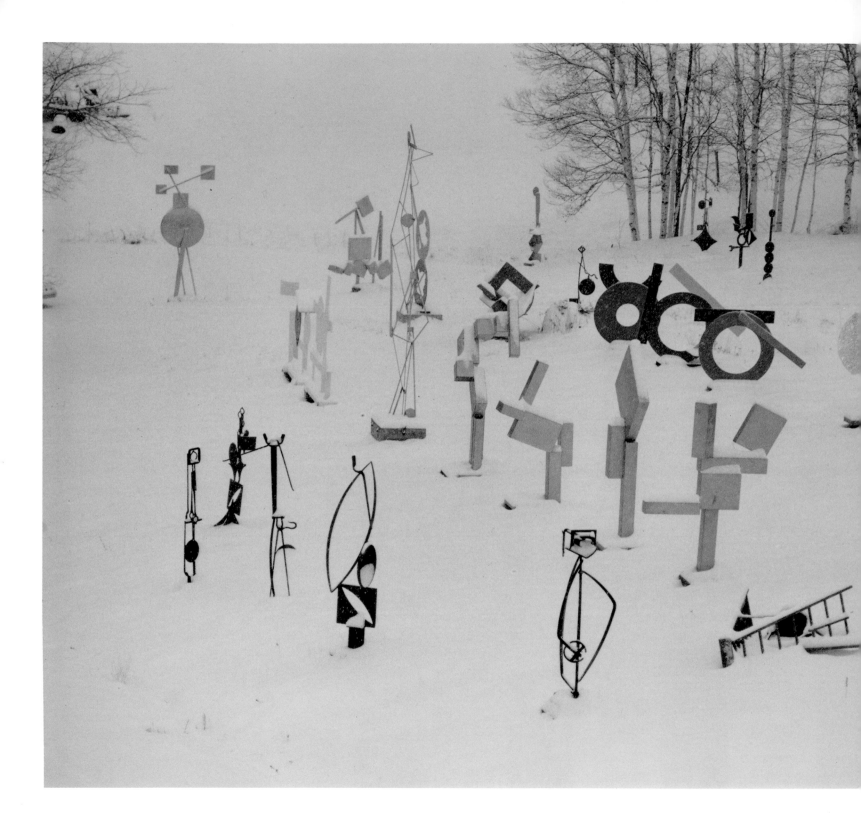

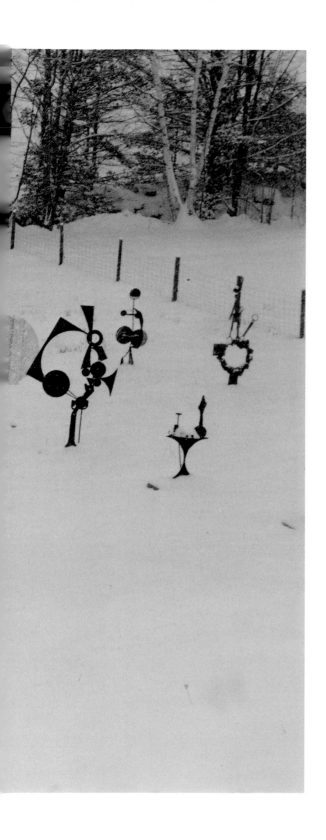

David Smith's North Field, Terminal Iron Works, Bolton Landing, New York, in the winter of 1963. Photograph by Dan Budnik

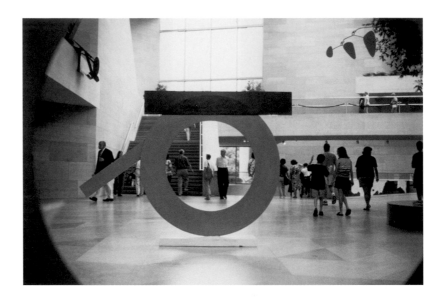

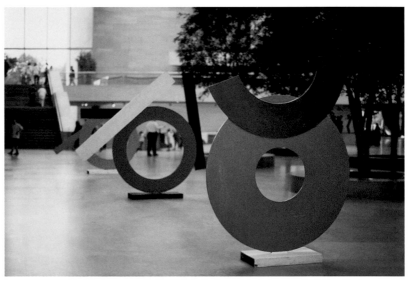

Figures 1a and 1b *Circles* by David Smith (American, 1906–1965) on display at the National
Gallery of Art, Washington, D.C.

This First of Forms: Smith's Circles

Michael Brenson

What is the profane if not the sum of objects abstracted from the totality? The sacred world is a world of communication or contagion, where nothing is separated and a special effort is required to remain outside the undetermined fusion.
—Georges Bataille

I.

In 1996, in preparation for a catalogue essay on David Smith, I visited the National Gallery of Art in Washington, D.C. On the ground floor of its East Wing, Smith's *Circle I, Circle II,* and *Circle III* (figs. 1a and 1b) were aligned so that their open centers formed concentric circles. The painted steel sculptures were crowd pleasers. With their slicing shapes and brisk colors and their hints of obstacle courses, parades, carnivals, shooting galleries, and signalmen, children loved them. Adults, too, liked mugging for one another through the apertures. The plank-like rectangles attached to the thin flat circles seemed not so much welded as slapped or glued on. How did the circles support their weight? The geometrical forms seemed to have jumped out of modernist abstraction. Released from the frame of painting, they seemed liberated. To people milling about them, these were sculptures with which to share a moment, or to be seen. I wasn't sure how to think about them, or what they were asking, but they were clearly conductors of energy—visual and performative events.

Another Smith sculpture, *Voltri VII* (fig. 2), was installed near the information desk some forty feet away. Five forged, flat, figurative verticals, each more or less S-shaped, were aligned in a row atop a horizontal bar supported at one end by two wheels and at the other by a wedge-shaped steel slab that seemed to drive downward and immobilize the "carriage" forever. Exposed as if on an auction block, the five silhouettes seemed naked and mournful, but in their back-to-back, belly-to-belly gyrations they also appeared to be dancing. Like the *Circles,* they seemed on display, although quietly, almost in a hush. *Voltri VII* carried ancientness within it. The *Circles* were not as overtly archaeological, but they, too, seemed as much extracted as made. *Voltri VII* included circles, but I responded to them as wheels, not as circles. I could see from the labels that *Voltri VII* and the *Circles* were all made in 1962, but *Voltri VII* was hauntingly evocative and the *Circles* more anonymous, and it did not occur to me that these sculptures were in fact made during the same year—just five months apart.

What most intrigued me about the *Circles* were their openings. Something seemed to be happening at their circular centers, where nothing was happening. Space seemed activated as it passed through these openings, for a moment gathering within the quarter-inch-thick rim of steel, in the process becoming neither air, void, emptiness, nor vacuum, but something that I could experience as and call *space.* Smith's space was not the psychological thickening around Alberto Giacometti's feverishly modeled postwar bronzes, which push light back while sucking it into their cratered surfaces. Its consistency was more various than the voids in the sculptures of Jacques Lipchitz, Henry Moore, Barbara Hepworth, Naum Gabo, or Antoine Pevsner, through the openings of which the development of negative space in modern sculpture has often been traced. Smith's *Circles* have no inside. No inner core. Everything in the sculptures is visible.[1] Yet even as the illusion of sculptural interiority was categorically rejected, the

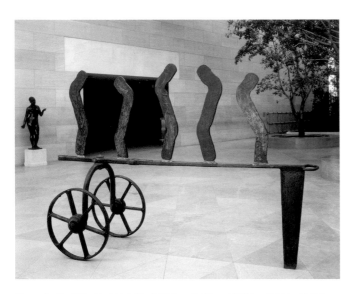

Figure 2 David Smith, *Voltri VII,* 1962. Iron, 84¹⁵⁄₁₆ × 122¹¹⁄₁₆ × 43½ in. (215.8 × 311.6 × 110.5 cm). National Gallery of Art, Washington, D.C. Ailsa Mellon Bruce Fund, 1977.60.4

openings *within* the *Circles* seemed inhabited. Cubism, after Paul Cézanne, had made the space in and around the object as important—as physical—as the object itself. In photographs by Brassaï and others, the space in and around Giacometti's *The Palace at 4 a.m.* was enchanted. The space within Smith's *Circles* seemed to come out of Cubism and Surrealism, out of paintings by Claude Monet, Paul Cézanne, Kazimir Malevich, and Paul Klee—out of a world of modern painting—as well, but to have its own density and magnetism. Smith's space depended upon European modernism, but it was different. It was not European.

How does one talk about these open centers? They can seem more or less substantive, depending on where and how they are shown, and for many people they won't be experienced

as spaces, just as holes cut out of flat steel rings. In his photographs and words, Smith provided clues as to how he wanted his work seen. It is clear from his photographs of the *Circles* on his 80-acre farm in Bolton Landing, New York, in the Adirondacks, that the spaces within their centers had their own materiality. "There is not even form, as we traditionally know it," Smith said in a 1952 talk:

> There is no chiaroscuro of solid bodies; now space becomes solid, and solids become transparent. . . . Nothing is really unsolid. Mass is energy, space is energy, space is mass. Whether such things are scientific facts is very, very unimportant. Art is poetic. It is poetically irrational. The irrational is the major force in man's nature. And as such the artist still deals with nature. Neither artist nor audience can deal with concepts that are not nature.[2]

Although Smith is known as a vertical sculptor whose welded-steel constructions arise from pedestals, the openings in the *Circles* insist on a horizontal perspective. Looking through them, the viewer never loses contact with the ground. At Bolton Landing, woods and land as well as other Smith sculptures were visible through these openings. They brought the preindustrial into the industrial eye of the work. What could be seen through the openings, one hundred or five hundred feet away, was part of the work. It was after Smith had seen his *Circles* within the landscape and against his other sculptures in the north field that he decided how to paint them. The push-pull between flatness and depth is as consequential as in any Cubist painting, but while the spatial dynamism in Cubism occurs for the most part within Parisian interiors, Smith's sculptures engage trees

and sky. Looking through Smith's *Circles,* an *out there,* or a beyond limits, or a radical elsewhere, becomes part of the dream and identity of the work.

Do the openings in the *Circles* evoke bellies and birthing and with them the inside of a body—a female body? Evacuated bellies? An energy source? Soul? (to move closer to the language of Ralph Waldo Emerson, the great American poet of the circle, the series, and identity). Emerson referred to "the due sphericity [of] the soul."[3] The openings are lenses. And eyes. Are the eyes wide open? All-seeing? Occupied and yet blind? "The eye is the first circle; the horizon which it forms is the second; and throughout nature this primary figure is repeated without end," Emerson's essay "Circles" famously begins. "It is the highest emblem of the cipher of the world. Saint Augustine described the nature of God as a circle whose center was everywhere and its circumference nowhere. We are all our lifetime reading the copious sense of this first of forms."[4] In another signature Emerson formulation, the eye is a passage. "I become a transparent eyeball; I am nothing; I see all; the currents of the Universal Being circulate through me; I am part or parcel of God."[5]

Like the Adirondack nature around him, and like him—or the way he imagined himself—Smith wanted his work to be boundless, endlessly self-generating and self-surpassing, a streaming, uncontainable, undifferentiatable excess. In order for his sculpture to achieve inextinguishable potency, it had to be endowed with sight. One of Walter Benjamin's definitions of *aura* is "looking back." Even as the openings in the *Circles* persuade viewers to look through them and define themselves first of all as viewers, viewers also can have the sense of being looked at.

II.

I began to think about Smith and space. In his iconic black and white photograph of his 1951 sculpture *Australia* (fig. 3), the sky seen through and around the wondrous linear choreography seems to circulate through this animal-vegetal-insect sculpture-creature. All that space out there, beyond the sculpture, seems to *want* the sculpture. In Smith's photograph, space seems to become the sculpture's garment and body. In the *Cubi* (fig. 4) sculptures of 1961–5, while the sun and moon are drawn into the reflective steel, another kind of space seems to have been sealed within the cubic, rectangular, and cylindrical canisters, waiting for an archaeologist to reveal its secrets after a catastrophe. In *Zig III* (1963), space seems to become almost gooey in

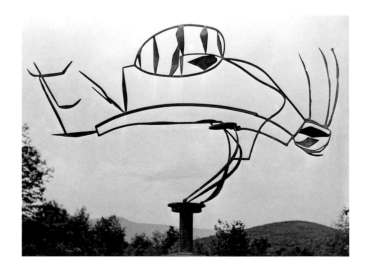

Figure 3 David Smith, *Australia,* 1951. Painted steel, 79 ½ × 107 ⅞ × 16 ⅛ in. (202 × 274 × 41 cm), on cinder block base, 17 ½ × 16 ¾ × 15 ¼ in. (44.5 × 42.5 × 38.7 cm). The Museum of Modern Art, New York. Gift of William Rubin. Photograph by the artist

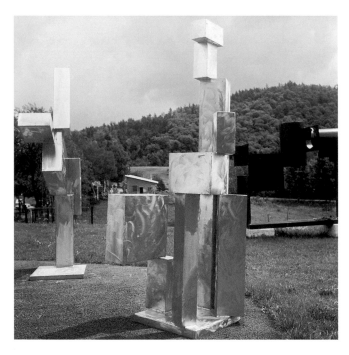

Figure 4 David Smith, *Cubi VIII*, 1962, and *Cubi IV*, 1963, Bolton Landing. Photograph by the artist

its thickness as it coalesces within a circular lens the size of a ship's porthole.

Smith drew pretty much every day, often at night in his house, after sculptural labor in his studio. He learned how to feel space by activating two-dimensional surfaces through gesture, line, color, and image. In the spray drawings, he lay an unpredictable array of objects on paper and sprayed enamel paint over them, then occasionally dripped and brushed more paint over the negative forms and their surrounding regions. In 1962, Hilton Kramer defined the process:

The stencil drawings are quick sculptural studies; they are arrangements and assemblages of forms— rectangles of cardboard, crescents of watermelon rind, metal rods—that are momentarily "fixed" on the page with a spray of paint, and then quickly improvised into still further arrangements and new inventions. (The metal colors, he says, suggest "a metallic frame of reference" for the sculpture.)[6]

Smith unleashed improbable configurations, such as those that he developed in the *Cubis* and *Voltris.* In the sprays he created magnetic fields of astonishing human, astral, architectural, and biological interpenetration.

In more traditional pencil drawings related to the *Circle* sculptures, the steel rings seem to lean against or into the paper, projecting their open centers forward.[7] In *Circles I, II,* and *III* the evenly applied matte paint seems to push against and even into the steel from both sides. Using a hard impress that suggests forging, Smith leans rectangles into the tops of two of the circular rings, and these rectangles show through the steel on the other side, making the steel seem like skin. In *Circle III* (checklist 4) the white base holds the circle down while the green crescent affixed to the top of the red ring squeezes and lifts it up. The effect of these formal pressures is to make the opening in the center seem as active as the centers within the concentric-circle series Kenneth Noland painted between 1958 and 1963 (fig. 5). Noland began these works by painting a solid circle in the center of an unprimed, unsized canvas. Then he painted concentric rings around it.[8] The results could be stunning in their electric dynamism. In his *Circle* sculptures Smith left the centers open and yet made them pulsate, like Noland's centers.

Figure 5 Kenneth Noland (American, 1924–2010), *Half,* 1959. Acrylic on canvas, 68⅝ × 68⅝ in. (174 × 174 cm). Museum of Fine Arts, Houston, Texas. Gift of Mr. and Mrs. Meredith Long

Smith and Noland were buddies. They met in 1951 through Cornelia Langer, Noland's first wife, who had been a studio art student of Smith's at Sarah Lawrence College. In 1949 Langer introduced Smith, then married to Dorothy Dehner, to her classmate Jean Freas. Dehner left Smith near the end of 1950. In spring 1953 Freas and Smith married. They had two children, Rebecca (born 1954) and Candida (born 1955). After Freas took them with her to Washington when she left Smith in 1958, he was allowed to see them just eight weeks a year. His need for his girls was overwhelming. During their six-week summer visits, he pulled out all stops to enchant them. He bought them a pony and then an Angus to keep the pony company, arranged piano and horseback lessons, convinced a concert pianist to perform on the hillside for their birthday party, and hired excavators to dig circular ponds in which they could row and hunt frogs. The *Circles* could be hoops for children to crawl through as well as for wild animals to run through. Maybe they are also characters in children's stories. *Circle III* suggests a cartoon head with Dumbo ears.

Noland considered Smith, who was eighteen years older, a mentor through whom he learned the ropes of the art world. Smith provided a model for how to work. From Smith, Noland adopted the idea of the series. Smith admired Noland's talent and wit, liked talking art and jazz with him, had fun with him, and saw in him a rising star who would keep him on his toes. Smith introduced Noland to Clement Greenberg, who had first raved about Smith in 1943 and whose critical support was invaluable to both artists.

Circles were essential to Smith from the moment he began welding sculpture in 1933. With his 1950 sculpture *The Letter*—with seventeen alphabetical characters, eleven of them *O*s, perched on four rungs—circles became the primary form in his work. In 1961, Smith gave Noland a seven-inch-tall figure-eight sculpture. Its lower circle suggests a wheel with spokes; the upper one is entirely open and its rim suggests cogs. Smith photographed himself leaning over the table on which the sculpture was placed, peering through the top circle, his right eye filling its lens (fig. 6). "He had that there, and I liked it," Noland said. "I'd been painting my circles by now, so he

18

Figure 6 David Smith with *Untitled (You, Me, and Uccello)*, 1961, in his living room, Bolton Landing, c. 1961

said, 'I'm going to give you that.' And he scratched on it, around the ring, 'You, me, and Uccello.'" Smith wrote: "This is for Ken Noland. Bolton Landing, 1961."

Noland described himself and Smith as "bad boys."[9] They raced cars up Smith's steep country road in the dead of night and, after Freas left Smith, competed for young women. "How is Mary—which of my girls are you tailing?" Smith wrote Noland before describing *Noland's Blues* (fig. 7), a 1961 sculpture in

which the head of a figure on a big diamond body is evoked by two circles. Painted in strokes of uneven thickness down the center of the diamond is a vertical red strip that has the energy of Willem de Kooning's slashing vertical gestures in paintings like *Ruth's Zowie* and *Bolton Landing.* "Blue black with red strip up pussy—that not in show—little too big," Smith wrote Noland, referring to an exhibition at Manhattan's Otto Gerson Gallery scheduled to open on October 10, 1961.[10]

When Smith's friends saw his *Circle Series,* they thought of Noland. "The first time I saw the three [*Circles*] they were in a triangular formation, and the next time I saw them he had straightened them out," photographer Dan Budnik said. "Eventually they were painted. And this fourth one [*Circle V*, checklist 1] was added. So when you stood at the aperture of the first one, looking up toward the main house, you realized it was a bull's-eye. That's what Noland was doing. He was doing bull's-eyes. So it was like an 'in' joke, almost like a visual secret that Smith had, that you wouldn't necessarily know about."[11]

Another artist, Tina Spiro, said, "they were definitely a dialogue with Ken, and they had that kind of a friendship. It was like a competition and a bantering, and a love and respect. It was a real push-pull kind of relationship. Those were like an 'in dialogue' with Ken's paintings."[12]

Noland was a great colorist. "I wanted color to be the origin of the painting. . . . I wanted to make color the generating force." Smith needed color to work in relation to sculpture, almost always in a way that would fuse it with metal while retaining its separateness. Through circles, Noland wanted to make "single, expressive entries" that could break away from syntax and composition.[13] Smith's constructions include continuous elements, like circles, but make a point of discontinuity. Their

stability or balance—what makes them or anything else stand—is in question. Their syntax is mysterious. Sculptor Robert Murray was one of many younger sculptors who had to come to terms with Smith's constructive imagination.

> He was the godfather, so to speak, of sculpture, as far as my generation was concerned. But then, where do you go from there?. . . Smith made such a powerful statement. He was just a hard act to follow. . . . What do you do after Smith? Do you copy Smith? Where do you go?. . . The thing that intrigued me with sculpture was the idea, again—as had been done more in painting—. . . was it possible to make it all of one thing, and not an assemblage of parts?[14]

III.

The titles of Smith's *Tanktotem* and *Agricola* sculptures establish them as both familiar ("tank" and "agri") and eccentric; the familiar morphing into the less or the unfamiliar. *Cubis* and *Zigs* refer to known forms—cubes and ziggurats—but in ways that make Smith's relationship to them personal. By contrast, the title *Circle* has no particularity or personality. *Circle* is a generic word; the circle is a universal form, at once symbol, idea, and image. Smith considered the circle a found form: one everybody could relate to and use, and beyond property or ownership. In 1964 when art critic Thomas B. Hess, then the executive editor of *Artnews,* asked him, "What's the idea behind the found object as far as you're concerned?" Smith, echoing Cézanne, who found the cylinder, sphere, and cube in nature, responded: "Are triangles, circles, and spheres 'found'? They have always been there. Painters don't 'come upon' subjects for a still life; the Impressionists didn't come upon their subjects. They found their trees, they chose their apples; those are all 'found objects'—flowers, fruit, everything."[15]

Through the circle Smith could embrace the history of art, Western and non-Western, from prehistory to the present. In the late 1950s the form was essential not just to Noland but also to Adolph Gottlieb, his Brooklyn Heights neighbor in the 1930s, who occasionally painted one circular burst on top of another, the bursts together resembling a figure eight. The circle was essential to Vassily Kandinsky, perhaps the only modernist who used circles as frequently as Smith, as well as to Klee and Henri Matisse, whom Smith also revered,

Figure 7 David Smith, *Noland's Blues,* 1961. Painted steel, 99⅛ × 44¼ × 20½ in. (251.8 × 112.4 × 52.1 cm). Private collection. Photograph by the artist

and to Fernand Léger, an influential figure within the leftwing art and politics circle to which Smith belonged in the mid- to late 1930s. The circle was a staple of Constructivism, Robert Delaunay, and many other artists exploring geometric abstraction. The form was an inspiration to Paolo Uccello, Filippo Brunelleschi, and another great Renaissance geometer, Piero della Francesca, a hero of another of Smith's friends, Philip Guston. The bicycle wheel is a signature object of Marcel Duchamp, who was also a part of Smith's encompassing artistic family. Smith acknowledged Duchamp's importance as the artist who displaced found objects into art and asserted that it is art if the artist says it is.[16]

In his catalogue essay on Noland's circles, William C. Agee keeps returning to Jackson Pollock, who, with de Kooning, was the painter against whom Smith most gauged his artistic achievement. Noland believed that when Pollock spread the canvas on the floor and painted into it from around the sides, occasionally stepping into it, he made the center an urgent question.[17]

In Smith's work, the meanings of the circle seem inexhaustible. It can delineate a space of ritual: the *Circles* and *Voltri VII* are among many Smith sculptures that evoke sacrificial acts. In *Voltri XX,* the ring near the middle of a Chaplinesque fighting figure evokes a belly. The object presiding over the worktable of *Voltri XIX* suggests a star, sunburst, snowflake, and ferris wheel: if a line were drawn around the outer edges of its intersecting spokes, it would form the circumference of a circle. A circle can stand for the letter *O* and suggest the exclamation *Oh!*—in *The Letter* (fig. 8) it is both. Circles can be essential tools, like those Smith incorporated into his *Voltris* and *Voltri Boltons.*

In *Voltri XV* a large circular ring is welded to the top edge of a vertical beam. The five horizontal strips welded to the front and back of the ring squeeze it from both sides, helping to transform the opening into an invaded and protected opening that viewers are encouraged to look at and imagine passing through, although they can only enter visually. These horizontal strips also suggest clouds passing across the sun or moon. Or toy ships. Or blades over, or even into, an eye. The image of dulled, feeble, but still somehow functional knives transforming an opening into a forbidden obstacle hints at shamanic passage.

Wheels became prominent in Smith's work in the late 1950s and prevalent in the *Voltri Series.* "I've used wheels a lot," Smith told Hess. "As far as I know, I got the wheel idea from Hindu temples. . . . They cut them out of stone on the temples to represent the processions where they carry copies of temples down the streets on wagons. Carved stone wheels. It's a fascinating idea. I went to the Museum of Science and Industry, where they have square wheels."[18] Smith's wheels trigger another field of association: ancient chariots, automobiles, trains, circus cars, wagons, and dollies. The wheels on Smith's *Voltri* and *Wagon* sculptures bring to mind the chariots of Giacometti, which were inspired in part by those from ancient Egypt. Smith, too, studied Egyptian culture. Like the Hindu temple's carved stone wheels, Smith's wheels—some found and old, some commissioned or made by him—activate a desire for, and at the same time disable, movement. Even when his sculptures can move, as in *Zig IV* and *Black White Forward,* the wheels are so disproportionately small beneath a mass of steel that any pressure on these masses would, seemingly, cause the sculptures to topple and lie beached. Smith's wheels strengthen the presence of narrative. One question they seem to ask is:

Figure 8 David Smith, *The Letter,* 1950. Welded steel, 37 ½ × 25 × 12 in. (95.3 × 63.5 × 30.5 cm). Munson-Williams-Proctor Arts Institute, Utica, NY. Museum purchase, 51.37

Where have these sculptures been? They also seem to ask: What do they know? What do they want to do? Who or what is their diabolical designer?[19]

As a coin, the circle is a symbol of money; as a seal, a property stamp. As a target it authorizes aggressive intent. Several of the *Medals for Dishonor,* the watershed series of fifteen breathtakingly outspoken and esoteric antiwar, anticapitalist, low-relief bronze sculptures Smith made between 1937 and 1940, are circular disks inspired in part by Sumerian seals in the British Museum. Although the boundaries of three of the six circles seem deformed by the scenes of savagery within them, in the *Medals* there seems to be no limit to the events the circle can reveal and frame. *Bombing Civilian Populations* (fig. 9) includes one of the fateful images in Smith's art: a woman with her belly torn open, its skin ripped back, "revealing," as stated in Smith's caption, "a thirteenth-century Caesarian." Near the center of this circle we see the fetus within her belly. The nearly circular head of the tall, violated woman projects forward from within the concentric circles of her hair. Alongside her a dead boy is impaled on the point of a bomb on the surface of which Smith inscribed his initials in Greek. A circle can be a symbol of wholeness and healing, but during the Great Depression and World War II such promises of relief could be cruelly delusional.

IV.

To my knowledge Smith never mentioned Emerson in a letter, notebook, or essay. For a midcentury American modernist in revolt against American provincialism, it was easy to cite Monet, Cézanne, Pablo Picasso, Julio González, James Joyce, Sigmund Freud, Arnold Schoenberg, and Martha Graham. Among members of his avant-garde generation, who felt liberated by European modernism, it was harder than it had been for Alfred Stieglitz's generation to acknowledge nineteenth-century American writers.

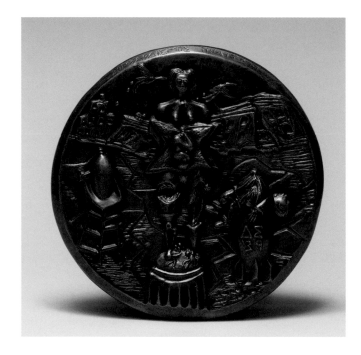

Figure 9 David Smith, *Bombing Civilian Populations,* 1939. Bronze, 10 in. (25.4 cm) diameter. The Estate of David Smith

In the creation myth Smith developed in the years immediately after the war, pre-twentieth-century America plays a formative role, but it is informed by his childhood and ancestry in Decatur, Indiana, and a mythical America of pioneers, settlements, and railroads along with American "vulgarity."[20]

Smith's modernist references cannot account for the American-ness of his spatial imagination, or the philosophy that is made visible by the *Circles* (fig. 10). The American spatial imagination Emerson helped to define was attached to notions of beginnings, horizon, variability, mutability, democracy, and nature. The spaces he evoked were vast and unsettled,

extensive and immanent. Even as Emerson was rooted in a particular place and body, where the eye was located, he wrote of the "centrifugal tendency of a man, to his passage out into free space" where he could "escape the custody of that body in which he is pent up, and of that jail-yard of individual relations in which he is enclosed."[21]

Emerson's call for a new poet inspired Whitman's epic embrace:

> I look in vain for the poet whom I describe. We do not with sufficient plainness or sufficient profoundness address ourselves to life, nor dare we chaunt our own times and social circumstance. If we filled the day with bravery, we should not shrink from celebrating it. Time and nature yield us many gifts, but not yet the timely man, the new religion, the reconciler, whom all things await. . . . We have yet had no genius in America, with tyrannous eye, which knew the value of our incomparable materials, and saw, in the barbarism and materialism of the times, another carnival of the same gods whose picture he so much admires in Homer; then in the Middle Age; then in Calvinism.[22]

Both Emerson and Whitman were taught at Paulding High School in northwestern Ohio when Smith was a student there from 1921 to 1924, shortly before he fled the small-town Midwest. The summer before settling in New York, he took poetry courses at George Washington University in which he again encountered Emerson. Robert Henri, who taught John Sloan, with whom Smith studied at the Art Students League, revered Whitman and Emerson. Sloan admired both writers as well. "Whitman's love for all men, his beautiful attitude toward

the physical absence of prudishness. . . all this represented a force of freedom," Sloan wrote.[23] With the help of Sloan, a salty, leftwing firebrand, Smith developed an American cultural base before Jan Matulka (with whom Smith later studied) and John Graham introduced him to European modernism. Stuart Davis, who became something of a mentor to Smith in the 1930s, was also an avid reader of nineteenth-century American writing. Whitman was "our one big artist," Davis wrote in his journal.[24]

After World War II, artists who would come to be known as Abstract Expressionists turned away from a ruined and discredited Europe toward American culture. While the art of earlier American modernists was not of much use to them, however much they respected artists like Stieglitz, John Marin, Arthur Dove, and Albert Pinkham Ryder, the transformative achievements of nineteenth-century American writers seemed freshly available. Earlier in the century Whitman had been an American cultural hero. "As the only American figure in any of the arts equal to European artists, Whitman was the only real vanguard American artist about whom one could speak without embarrassment," Matthew Baigell wrote.[25] By 1920 Whitman and Emerson were embedded in American artistic culture. In his essay "The Emersonian Presence in Abstract Expressionism," Baigell wrote that although he discovered no specific references to Emerson, he found his presence within Abstract Expressionism to be incontrovertible. "With Abstract Expressionism, the Emersonian presence can be felt most profoundly in the late '40s," through the work and words of Pollock, Barnett Newman—a friend of Smith's whose work he came to admire only slightly less than Pollock's and de Kooning's—and Clyfford Still.[26]

Despite basic differences between them in temperament, style, and outlook, it is hard to imagine Smith without Emerson. Harold Bloom remarked on Emerson's dialectical mind—"so astonishing a receptivity to opposites"—which can be said of Smith as well.[27] They also shared an interest in what Stanley Cavell described as "the common, the familiar, and the low."[28] Smith would have found many other affinities with Emerson: his shifting moods ("Our moods do not believe in each other"[29a]); his belief in the private self, in the individual, as a way of finding others ("To believe your own thought, to believe that what is true for you in your private heart is true for all men—that is genius. Speak your latent conviction, and it shall be the universal sense; for always the inmost becomes the outmost."[29b]); his realism ("Why should we fear to be crushed by savage elements, we who are made up of the same elements?"[29c]); his alignment of creativity with transition ("Power ceases in the instant of repose; it resides in the moment of transition from a past to a new state, in the shooting of the gulf, in the darting to an aim. This one fact the world hates, that the soul becomes."[29d]); and his belief that every insight and accomplishment is only a beginning—"There is no virtue which is final; all are initial"; "Every ultimate fact is only the first of a new series."[29e] Smith, too, would have found this initial-ness essential to the American identity. As Cavell writes, "it is our poverty not to be final but always to be leaving (abandoning everything we have and have known), to be initial, medial, American."[30]

As with Smith, Emerson's creativity is distinguished by momentum: *onwardness* was one of Emerson's defining words. In the current of his onwardness, dark moods were almost immediately swept up within its flow. Emerson, too, believed perception was decisive—"Perception is not whimsical, but

fatal," he wrote[31]—and he also felt the importance of remaining rooted in the American landscape. Emerson's thought process is so evident in his writing that the movements of his mind are integral to the experience of reading him. He, too, produced a creative outpouring that makes it and him seem boundless. Bloom notes that "attempting to write the order of the variable winds in the Emerson climate is a hopeless task."[32]

The circle is a recurring image and metaphor for Emerson. In his essay "Circles," it is an eye and also an encompassing material blankness: "the highest emblem of the cipher of the world."[33] It is a metaphor for personal growth: "The life of man is a self-evolving circle, which, from a ring imperceptibly small, rushes on all sides outwards to new and larger circles, and that without end. The extent to which this generation of circles, wheel without wheel, will go, depends on the force or truth of the individual soul." The law of the circle identifies humanness with vulnerability—we can "at any time be superseded and decease"—which necessitates incessant onwardness in order not to be terminally consumed. Arriving at new and bolder "generalizations" requires abandon, spontaneity, and intuition, and these were principles of Abstract Expressionism as well. "The one thing which we seek with insatiable desire is to forget ourselves, to be surprised out of our property, to lose our sempiternal memory and to do something without knowing how or why; in short to draw a new circle."

The circle is a metaphor for that agonistic process by which people inscribe and are inscribed by other conceptual frames. "His only redress is forthwith to draw a circle outside of his antagonist." In Emerson's proto-avant-garde understanding of progressive development, a new circle can be tumultuous: "A new degree of culture would constantly revolutionize the entire system of human pursuits." The past can be shed: "In nature every moment is new. The past is always swallowed and forgotten; the coming only is sacred. Nothing is secure but life, transition, the energizing spirit. . . . No truth so sublime that it may be trivial tomorrow in the light of new thought. . . . I unsettle all things," Emerson wrote with Abstract Expressionist bravado. "No facts are to me sacred; none are profane. I simply experiment, an endless seeker with no Past at my back."

Smith was capable of grandiose rhetoric. "I feel no tradition," he wrote in a statement that Baigell and Max Kozloff have described as Whitmanesque (and which also could be considered Emersonian). "I feel great spaces. I feel my own time. I am disconnected. I belong to no mores—no party—no religion—no school of thought—no institution. I feel raw freedom and my own identity. I feel a belligerence to museums, critics, art historians, aesthetes and the so-called commercial forces in a commercial order." [34] Despite such bravado, however, Smith wanted his work to belong as much to the past as to the present and future, and he believed deeply in the idea of artistic family. For him, artists made up a guild, a special community, in a world in which the creative individual was perpetually threatened with misapprehension and exploitation. In his art and words he embraced the artists and artworks he cared about. In his acts of encompassing, they were both present and changed.

To philosopher David Van Leer, the endless process of creating circles around other circles builds an archaeological dimension into the production of knowledge. "[Emerson's] 'Circles' is finally not about how human beings feel, or even how images work, but about what concepts are buried in other concepts."[35]

In the circle, and in circling, the life force is joined: "Whilst the eternal generation of circles proceeds, the eternal generator

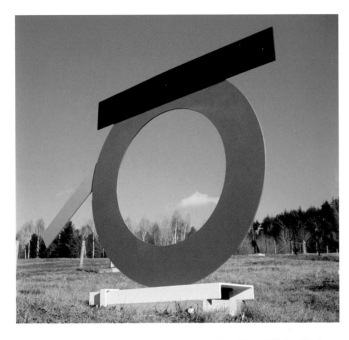

Figure 10 *Circle I*, 1962. Painted steel, 79 × 107 $^{11}/_{16}$ × 18 in. (200.7 × 273.5 × 45.7 cm). National Gallery of Art, Washington, D.C. Ailsa Mellon Bruce Fund, 1977.60.1. Photograph by the artist

resides." Emerson refers to the center: "Saint Augustine described the nature of God as a circle whose center was everywhere and its circumference nowhere." This center is available and inaccessible. It can be understood as a continual coalescing, a gathering of energy and soul that can feel like the forming of place and ground and at the same time as a denial of the possibility of foundational solidity. The center is outside and inside. It advances and recedes. It is in the surface and infinite in extension, here, now, and elsewhere.[36]

Emerson believed in the great man. The "circular philosopher" is someone the rest of society is looking for. He is "the oracular genius" who has the ability to liberate the potential of others. "Every man is not so much a workman in the world as he is a suggestion of that he should be. Men walk as prophecies of the next age." Through contact with this man and his work, others begin to find themselves as they move closer to what they can be and into other orbs.

In a 1952 talk at the Museum of Modern Art, Smith called upon a range of words to communicate the meanings of black:

> When you ask the question to black—Is it white? Is it day or night, good or evil, positive or negative? Is it life or death? Is it the superficial scientific explanation about the absence of light? Is it a solid wall or is it space? Is it paint, a man, a father? Or does it come out blank having been censored out by some unknown or unrecognizable association? There is no one answer. Black is no one thing. The answer depends upon impression. The importance of what black means depends upon your conviction and your artistic projection of black; depends upon your poetic vision, your mythopoetic view, your myth of black. And to the creative mind the dream and myth of black is more the truth of black than the scientific theory or the dictionary explanation or the philosopher's.[37]

For Emerson, the circle was symbol, poetic vision, mythopoetic view, myth and dream, and more. Being all this at once, drawing a circle around the circle was unimaginable. The economy of the image was incommensurate with the profusion of words and images needed to emancipate its multiplicity and potential.

V.

Like Smith's fifteen other sculpture series, the *Circles* seem to come out of nowhere and to develop at an unpredictable pace. The first four were completed within a week during October 1962. The date Smith welded onto *Circle V* is "9-10-63." At a certain point, each series stops so arbitrarily that it is impossible to believe it is over. Since the circle is a symbol of continuity, ending the *Circle Series* after only five sculptures is tantalizingly abrupt. In this series, too, the numeration is antilinear. Smith dated *Circle IV* (checklist 5) after *Circle I* (checklist 2) and before *Circles II* (checklist 3) and *III*. Each sculpture in a Smith series varies in size and imagery. Every Smith series includes at least one oddball. Is *Circle IV* part of the same family? Smith installed *Circles I, II, III,* and *V* in his sculpturally cluttered north field. He installed *Circle IV* in the south field, overlooking Lake George, where his sculptural arrangement was expansive and serene.

Circle IV is figurative. Its main orientation is vertical. Its rounded flat mass suggests a slightly lopsided torso-belly, the two triangular slabs below it recall Giacometti's oversized sculptural feet. The figure seems to look back to Picasso as well, perhaps a boy with a hat. The sculpture is not open in the center. It does not contain a full circle: the perimeter of its circular form is not continuous. The sculpture has not just two dominant sides, but is fully three-dimensional, shifting dramatically from one point of view to the next. Like *Circle I* and *Circle II, Circle IV* contains a rectangle, but this one seems to slice the sculptural neck. Perpendicular to the rest of the body, it hints at a weapon.The *Circles* were made at the height of the Cuban Missile Crisis. If *Circles I, II,* and *III* resemble bull's-eyes, then with *Circle IV* the series includes a weapon to fire at them.

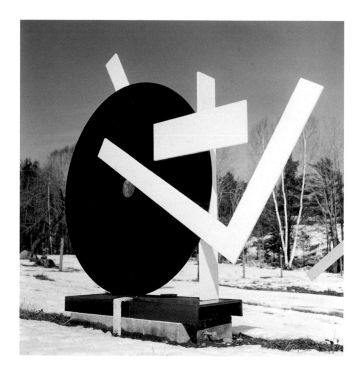

Figure 11 *Circle V*, 1963. Painted steel, 77 × 90 × 20 in. (195.6 × 228.6 × 50.8 cm) JPMorgan Chase Art Collection. Photograph by the artist

The color and paint application are different as well. *Circles I, II,* and *III* show little evidence of the artist's hand. Paint was applied with industrial brushes, and the surface uniformity and hard edges bring to mind the reaction against the painterly that helped define post-painterly abstraction, which Clement Greenberg identified with "a relatively anonymous execution," "geometrical regularity of drawing," and "trued and faired edges" that "get out of the way of color." "The painterly," he wrote, "means, among other things, the blurred, broken, loose definition of color and contour."[38] By the

late 1950s, the painterly was, he wrote, a sign of a moribund Abstract Expressionism.

Circle IV is painterly. The application of paint has a handmade insistence. The colors are muddier or murkier than those in *Circles I, II,* and *III.* The wavering edge at the point where the red and white sections meet is a tenuous juncture. In this sculpture nothing seems to fit. While each section of *Circles I, II,* and *III* has an all-at-onceness, *Circle IV* seems to have come together slowly, with spare parts. Paint and steel are decidedly not in harmony. Edge is not line. *Circles I, II,* and *III* are sleek, clean, and—even with objects attached to the rings—unencumbered. *Circle IV* offers discovery through slow, intimate attention.

Circle V clearly belongs to the same family as the first three *Circles* but, completed nearly a year later, it, too, seems to have come out of nowhere (fig. 11). The large mother form of the *Circle* is black. Because the hole in the center is tiny, the surrounding flat ring, and with it the sculptural body, seem fat. "The life of man is a self-evolving circle," Emerson wrote, "which, from a ring imperceptibly small, rushes on all sides outwards to new and larger circles, and that without end."[39] With *Circle V,* the series gained a small ring out from which the other three openings can ripple. The base is painted brown. Four flat, rectangular, white steel strips are affixed or adjacent to the black circle. A rectangle on top runs parallel to the base. While the language is essentially Constructivist in its vocabulary of circle, rectangle, and cross, the tone could be Dada or Surrealist. The tiny opening seems ribaldly lewd; the four concentric circles can be read as a dilating and contracting orifice. The black circle seems at the mercy of the other forms, to which it can only submit—not unlike a Hans Arp sculpture in which small biomorphic forms seem to crawl over a larger biomorphic body.

Circle V emphasizes yet another kind of looking. Throughout the series the opening's association with a lens is clear. The concentric openings that Smith made a point of in his sequential outdoor installation make the lenses in *Circles I, II,* and *III* telescopic. In *Circle V,* the association is with a camera. The large *L* is akin to a lever, and it intrudes down slightly, over the aperture. This gives the opening the sense of a camera lens. An exposure seems in the process of being made. By what? By whom? Is the sculpture shooting us?

During Smith's lifetime, painting remained the primary artistic medium. It continued to be largely synonymous with *art.* Since paintings commanded much higher prices and received more critical and curatorial attention than sculptures, winning the competition with painting and raising sculpture from its subservient position was for Smith an economic necessity as well as an aesthetic challenge. In one sculpture after another, Smith made the point that sculpture could outdo painting. It could encompass painting.

He wanted his sculpture to encompass photography as well. *Circles I, II, III,* and *V* are obviously not cameras but, like them, they provide a unique way of seeing—through a lens. Beginning with sculptures in the early 1950s, such as *The Letter, Big Diamond, O Drawing,* and *Agricola IX,* there are many examples of Smith circles that encourage viewers to feel that when looking through their lenses they see not just differently but *better.* Smith's sculpture makes the lens an inescapable feature of the viewing experience. In his insistence on acutely self-conscious looking, he may have drawn a circle around those art historians who are confident that their categories have relegated him to a defunct time. It is hard to imagine drawing a circle around him.

Notes

Georges Bataille, "War and the Philosophy of the Sacred," in *The Absence of Myth: Writings on Surrealism* (London: Verso, 1994), p. 114

1 Rosalind E. Krauss, *Passages in Modern Sculpture* (Cambridge, Mass.: MIT Press, 1981)

2 David Smith, "The Sculptor and His Problems," in Garnett McCoy, ed. *David Smith* (New York: Praeger, 1973), pp. 106–7

3 Ralph Waldo Emerson, "Experience," in *The Selected Writings of Ralph Waldo Emerson,* ed. Brooks Atkinson (New York: Modern Library, 1992), p. 324. While thinking about Smith's *Circles,* I read Ann Lauterbach's book *Under the Sign* (New York: Penguin, 2013), in which Emerson is a major presence, as he has been throughout her writing. The poem that ends the book, "Song of the O (Emerson 'Circles')," led me to Emerson's essay "Circles." Ann also led me to Emerson's essay "The Poet" as a way of tying Emerson to Whitman.

4 Emerson, "Circles," in *Selected Writings*, p. 252

5 Emerson, "Nature," in *Selected Writings*, p. 6

6 Hilton Kramer, "David Smith: Stencils for Sculpture," *Art in America* 50 (winter 1962): pp. 41–42

7 E. A. Carmean Jr. reproduced five of these drawings in "The Circles," the first substantial essay on this Smith series. E. A. Carmean Jr., *David Smith* (Washington, D.C.: National Gallery of Art, 1982), p. 137

8 William C. Agee, *Kenneth Noland: The Circle Paintings 1956–1963* (Houston: Museum of Fine Arts, 1993), p. 15

9 Brenson interview with Kenneth Noland, April 7, 2001

10 David Smith letter to Kenneth Noland, September 25, 1961. (All Smith-Noland correspondence is from Noland's personal archive.)

11 Brenson interview with Dan Budnik, October 25, 2001. Budnik first visited Bolton Landing in December 1962.

12 Brenson interview with Tina Spiro, December 3, 2006

13 Agee, *Kenneth Noland: The Circle Paintings 1956–1963,* p. 28

14 Brenson interview with Robert Murray, May 18, 2006

15 Thomas B. Hess, "The Secret Letter," in McCoy, *David Smith,* p. 175

16 Smith mentioned Duchamp on a number of occasions, including a March 1955 talk, "The Artist and Nature," and a May 1960 talk, "Memories to Myself" (see McCoy, *David Smith,* pp. 118 and 153). Smith appreciated Duchamp as one of the artists who paved the way for his often defiant belief in the freedom of the modern artist to determine what art was and what artists would make.

17 Agee, *Kenneth Noland: The Circle Paintings 1956–1963,* p. 23

18 Hess, "The Secret Letter," p. 185. Four years earlier Smith had characterized some of his sculptural "monsters" as "big constructions which have wheels. Sometimes the wheels work and sometimes not. But the wheels have meaning, they are no more functional than wheels on an Indian stone temple. It is a playful idea projecting movement." Smith, "Memories to Myself," p. 155.

19 For the connection between wheels and narrative, I am indebted to Kenji Fujita.

20 Smith leaned heavily on the word and notion of *vulgarity.* In "Memories to Myself" (p. 154), he wrote that "provincialism or coarseness or unculture is greater for creating art than finesse and polish. Creative art has a better chance of developing from coarseness and courage than from culture. One of the good things about American art is that it doesn't have the spit-and-polish that some foreign art has. It is coarse. One of its virtues is coarseness."

21 Emerson, "The Poet," in *Selected Writings*, p. 299

22 Ibid., p. 304

23 Matthew Baigell, *Artist and Identity in Twentieth-Century America* (Cambridge: Cambridge University Press, 2001), p. 16

24 Ibid., p. 22

25 Ibid., p. 14

26 Ibid., p. 142

27 Harold Bloom, "Emerson and Influence," in *Estimating Emerson: An Anthology of Criticism from Carlyle to Cavell,* ed. David LaRocca (New York: Bloomsbury Academic), p. 512

28 Stanley Cavell, *The Senses of Walden* (Chicago: University of Chicago Press, 1972), p. 142

29 All quotations from Emerson's writings in the paragraph from *Selected Writings,* as follows: [a] "Circles," p. 254; [b] "Self-Reliance," p. 132; [c] "Fate," quoted by Harold Bloom in "Mr. America" in *Estimating Emerson,* p. 499; [d] "Self-Reliance," p. 144; [e] "Circles," pp. 259, 254

30 Cavell, *The Senses of Walden,* p. 137

31 Emerson, "Self-Reliance," in *Selected Writings,* p. 144

32 Bloom, "Mr. America," in *Estimating Emerson,* p. 502

33 All quotations in this and the following paragraph are from Emerson, "Circles," in *Selected Writings,* pp. 252–62

34 Baigell, *Artist and Identity in Twentieth-Century America,* p. 12. The statement was clearly written in the years after the war, when the presences of Whitman and Emerson are most strongly felt in the words and art of the Abstract Expressionists. (The quote has been completed to correspond with its use in Cleve Gray, ed. *David Smith—Sculpture and Writings* [London: Thames & Hudson, 1968], p. 133.)

35 David Van Leer, *Emerson's Epistemology: The Argument of the Essays* (Cambridge: Cambridge University Press, 1986), p. 113

36 All quotations in this and the following paragraph are from Emerson, "Circles," in *Selected Writings,* pp. 252–62.

37 David Smith, "The Sculptor and His Problems," in McCoy, *David Smith,* pp. 87–88

38 Clement Greenberg, "Post Painterly Abstraction," in Clement Greenberg, *The Collected Essays and Criticism:* vol. 4, *Modernism with a Vengeance, 1957–1969,* ed. John O'Brian (Chicago: University of Chicago Press, 1993), pp. 191 and 197

39 Emerson, "Circles," in *Selected Writings,* pp. 252–62

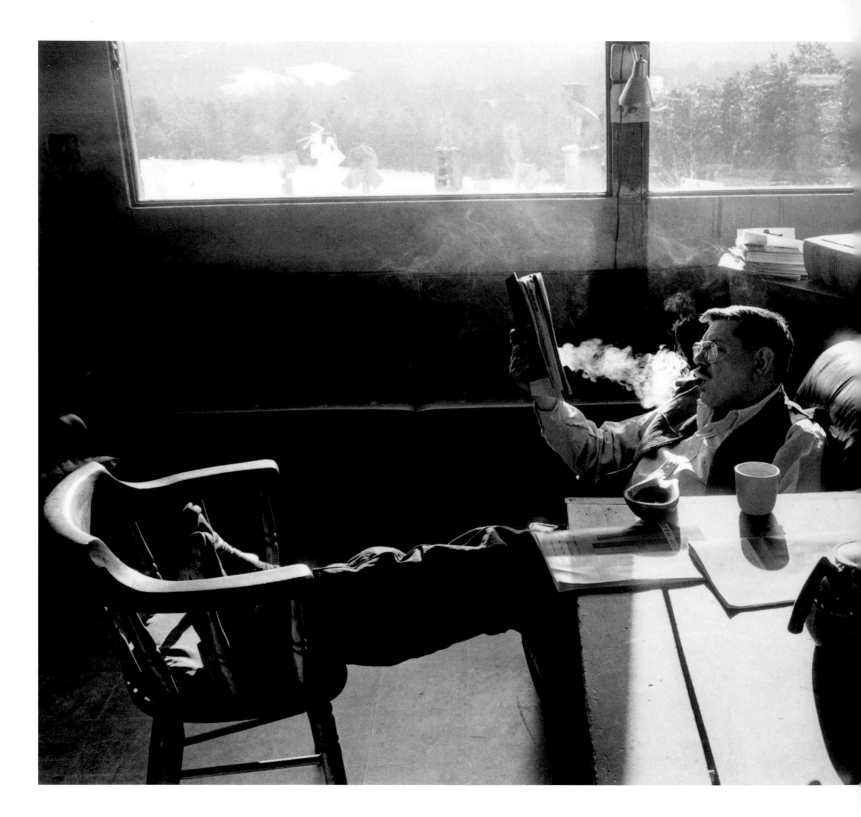

Smith reading at Bolton Landing, c. 1962–64. Photograph by Dan Budnik

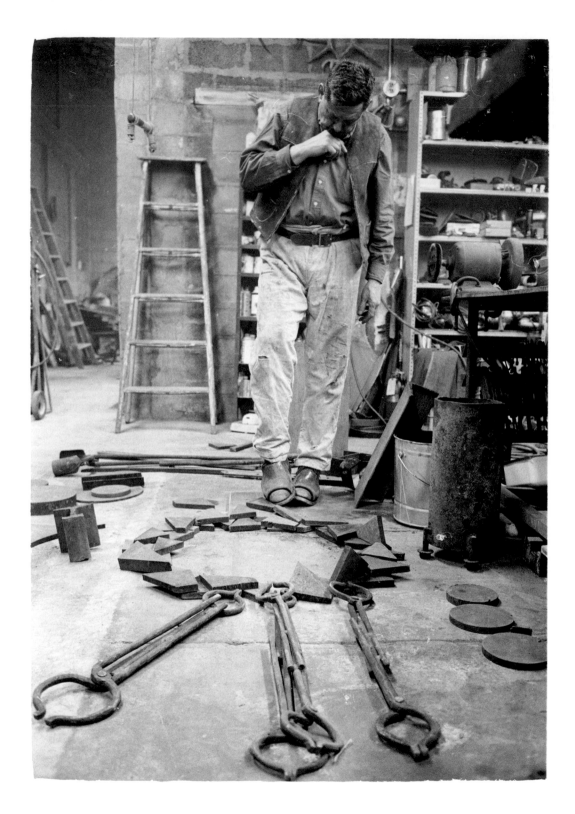

Figure 12 Smith with objects "toeing in" (David Smith working on *Voltri-Bolton X* in 1962). Photograph by Dan Budnik

Smith's Toe, Descartes's Doubt:
The Spray Paintings of David Smith David Breslin

An action is not a matter of taste. You don't let taste decide the firing of a pistol or the building of a maze.
—Harold Rosenberg

The modern painter cannot express this age, the airplane, the atom bomb, the radio, in the old forms of the Renaissance or of any other past culture.
—Jackson Pollock

In a 1962 photograph taken in his Bolton Landing studio, David Smith stands with his left hand hanging limply at his side (fig. 12). His right hand, the one customarily seen wielding the welder's torch in other photographs, here is pressed tensely into the crease between his bottom lip and chin. Unfixed pieces and parts—pincers and metal scraps—lie at his feet, waiting for permanence. But for now, each element is discrete; they are loose. With head tucked down so that brow and nose appear continuous, Smith studies the variety of parts in their contained sprawl. Amid the dormant geometry of steel placed, stacked, or strewn on the floor, his booted feet are cautiously animate. His straight left leg gives balance while the bent right one, with pointed foot, indicates that he is nudging mass. Work, that considered nudge suggests, is in progress.

Smith called this negotiation between steel and foot "toeing in." The movement suggests a process of refining or perfecting, a calculated adjustment that privileges measure over gesture. If art history has made a fetish of the footwork of Jackson Pollock, the improvised dance around the edge of the canvas that attended his brush's spray and splash, the chaste silence on the topic of Smith's toes is telling. Though Smith's output and energy are legendarily prodigious, the time- and labor-intensive nature of welding insisted that each act be a judicious one. If energy was to be expended, the result was one that was both desired and a product of Smith's labor. The

delicate touch of boot toe onto metal—which could be shifted only subtly by that slight push—runs against every masculinist fantasy of the artist as petulant actor and rash decider. It privileges slowness; it insists that certainty be shaped by a lived proximity to doubt. Smith's toe poses the questions: What if action could equally—and differently—be accented by its relationship to deliberation and doubt? What would happen if an associative language around action in relation to artistic practice could shift away from a certain prerogative afforded to impulse and chance—a language inseparable from Abstract Expressionism itself? How is doubt, contrary to suggestions from our "shoot first, ask later" culture, a strategy of aesthetic, political, and philosophical strength? In imagining the movement of that foot stilled in the photograph, one could liken it to the nervous gesture of the movie cowboy who traces time and worry on a patch of parched ground with a speculative boot, his hands deeply buried in back pockets. In that movie, a fateful decision always is acted upon even if repercussions aren't always seen on the screen.

In the late 1950s, when David Smith began making his spray paintings by placing objects both organic and synthetic on canvas and spraying commercial enamel on and around them, he created what could be considered counter lives for his sculptural productions. When the objects were removed from the canvas, the primed white ground remained. Shapes were

given definition, the objects were granted momentary stasis by the raw colors, those from industry and commercial life, which Smith chose and preferred. If the act of welding assures the constituent parts of a sculpture both a shared future and a *decisive moment* (the term Henri Cartier-Bresson suggestively coined in 1952 to define the impulsive recognition of the act to be photographed), the negative spaces within the spray paintings suggest qualities such as interchangeability and mutability. In the same year as the photograph described above was taken, Hilton Kramer described versions of the sprays on paper as "quick sculptural studies. They are arrangements and assemblages of forms—rectangles of cardboard, crescents of watermelon rinds, metal rods—that are momentarily 'fixed' on the page with a spray of paint, and then quickly improvised into still further arrangements and new inventions."[1] If possibility, even promiscuity, is the vital promise of the *Sprays'* materials (if not the arranger of those materials himself), is the other side of that coin a condition that could be characterized by indecision or second-guessing? If this formal recourse to procedures of rearrangement doesn't manifest an inability to act—there are far too many sculptures in the oeuvre to suggest this—could it be safely hazarded that Smith's adoption of this iterative potentiality implies a strategy of testing, deliberation, and caution?

If I belabor this rethinking of the terms of action, it is to revalorize something like the skepticism or doubt that René Descartes established as fundamental in his 1641 *Meditations on First Philosophy,* and that I see as operative in Smith's practice. In the *Meditations,* Descartes doesn't dismantle the possibility of truth. Rather, his methodological skepticism systematically strips away opinions in order to build solely upon a foundation of the unassailable. Action, in Descartes's system, isn't to be feared. The unconsidered outcome of a wanton action is what is to be avoided and deplored.

Evidence of Smith's detesting the rashly considered abounds and can be seen as early as his *Medals for Dishonor.* Created between 1937 and 1940 after a formative prewar trip to London where he studied, among other things, Sumerian and Egyptian seals, these plate-sized medallions depict the brutal and dehumanizing consequences of war in a style that assimilates Surrealist mythology, fantasies of prehistory, and antiwar and antibourgeois caricature reminiscent of the Weimar period in Germany. In an interview with Katherine Kuh in 1962, he discussed his motivations for creating this body of work. Smith, who was widely admired by friends and peers, such as Robert Motherwell, for his unwavering dedication to social justice and pacifism, said:

> The immediate reason for doing the *Medals of Dishonor* [*sic*] probably grew out of a series of postcards I bought at the British Museum, showing special war medallions the Germans awarded in the First World War, medallions for killing so-and-so many men, for destroying so-and-so many tanks, airplanes, et cetera. That aroused my interest in medals. From a naturally anarchistic, revolutionistic point of view, the idea of 'medals for dishonor' became my position on awards.[2]

In *Death by Bacteria* (1939; fig. 13), three hands hover in an apocalyptic sky over a wasteland (or is it a wasted sea?) strewn with corpses, coffins, skeletons, burial crosses, and

liquid-carrying (or spilling) vessels. The largest hand holds two spewing test tubes that spill into the sky like smokestacks disgorging fumes. A harp—symbolizing, as Smith divulges in a note, "death music"—joins the two other hands. One pours the noxious bacteria from an opaque vessel into a clear one; the other contains a human fetus within its palm while it grasps a rat whose feces is being extracted for cultures—a damning scatological reference both to the production of bacterial poison and to an inherently contaminated society. Each disembodied hand labors on its own, seemingly unaware of what the other does, let alone of what uncoordinated and ill-considered production it ushers into the world. While the tragic, if not evil, effects of poison gas used in World War I would have been widely known by 1939, the prospect of Treblinka or Auschwitz-Birkenau still would have been unthinkable despite the ferocity and barbarism of the fascist-backed Spanish Civil War that prefigured the looming disaster of the Holocaust. If Smith forecasts the catastrophic, concatenated endpoint of war and boundless technological and scientific "progress," it is not because he is a sage or has powers of divination. Instead, his ability to see—and then to make—the terrifying vanishing point where considered and deliberate action is lost is a result of a radical skepticism inseparable from a profound rationality.

But what does this have to do with spray paintings produced almost two decades later, on the other side of not just World War II, but the Korean War as well, in a style that eschews myth and representation for abstraction or, at best, absent figuration? If we look at Smith's *First Ovals* (1958; fig. 14 and checklist 10), linear shapes such as voided paint-mixing sticks rub against bulbous sacks that equally call to mind hypertrophic

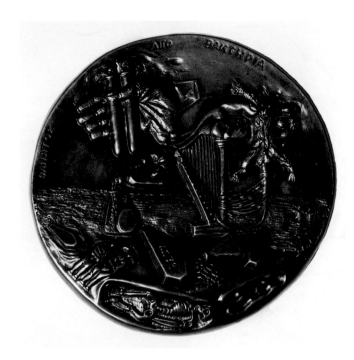

Figure 13 David Smith (American, 1906–1965), *Death by Bacteria*, 1939. Cast bronze, 10 in. (25.4 cm) diameter. The Estate of David Smith

bladders and kidneys or errant thought bubbles from the comics. Near ovals flank gourd-shaped protrusions. A slice of circle that calls to mind a car's wheel well floats free. It touches nothing but the black spray enamel that gives it definition—if absence can be said to have that quality. Other shapes are less distinct amid the profusion of blues, blacks, and splatters and spits of color. We don't have language for their geometries. We can assume that some of the more attenuated forms—such as those reminiscent of limbs or distressed driftwood—are of

36

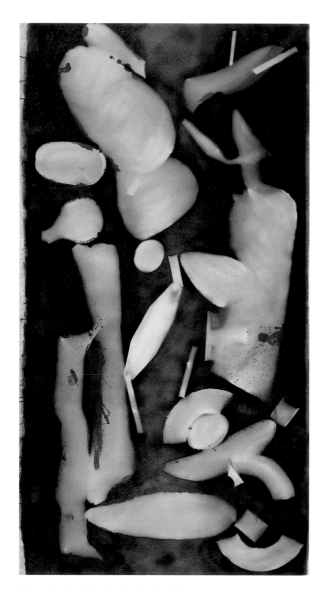

Figure 14　David Smith, *First Ovals,* 1958. Spray enamel on canvas, 98 ½ × 51 ¾ in. (250.2 × 131.4 cm). The Estate of David Smith

Smith's own manufacture. Though we can tell by the intensity of the spray where more paint was applied, it is nearly impossible to distinguish how Smith arrived at the composition:

When was each object laid down? How many objects were tested as suitable placeholders only to be rejected? How many configurations were tried before this one was deemed as true?

While this litany of questions picks at the process of each *Spray*'s manufacture, it also insists that the doubt signified by the dangling toe in the photograph also is at work in these acts of measured experimentation. As the rise of fascism in Europe and the Spanish Civil War historically situate the *Medals for Dishonor*, is there a similarly apposite context of political or social agitation that might historically ground the assured timidity—the confidence in doubt and reticence to act—evinced by the *Sprays*?

After a long day of wrestling with fire and steel, Smith sits, as he does in a photograph by Dan Budnik and as I imagine him, in his leather chair, feet propped and crossed on a wooden one (see pages 30–31). A cup of something is next to him, and his cigar already has been partially smoked down. Other periodicals would be among the art magazines on the table and in the room. We know that he read *Life* and perhaps also *Time.* Maybe an issue of one of those is what he grips into a bundle in his hand. Maybe it is the direction of the white smoke he expels, the initial orbital plume and puff that dissipates into a thinner shaft, that permits my projection. I see, almost with apology, this burst of smoke as a mushroom cloud laid low. Approaching a cover, say of *Life,* that might have featured the indelible image of that cloud that seems always to ascend, even in its cascading declension, the cigar smoke could be meeting its atomic other. Featured numerous

times on those magazines' covers since the September 17, 1945, issue of *Life* (which paired it with the simple caption "What Ended the War"), the cloud became both the emblem of the Cold War madness of mutually assured destruction and a testament to the American era of the technologically sublime. No less a figure than J. Robert Oppenheimer, the so-called father of the atomic bomb, could say, "When you see something that is technically sweet, you go ahead and do it and you argue about what to do about it only after you have had your technical success. That is the way it was with the atomic bomb."[3]

But arguing, with himself and with his materials, is the domain of Smith's deliberation, a form of worried making that enacts the difficult action of pacifism. Looking back at *First Ovals,* it is hard not to see it as anything other than a field of loss, where bodies are as valued as objects, where gravity—contradicting the insistent intensity of the spray itself—has been withdrawn. But it is a rehearsal for loss that Smith prepares with each painting, a deliberation not only of what is, but of those things that, in a blinding flash, never again will be. Consider the view Smith had from his window (see pp. 30–31), a view that included his snow-covered fields, trees licked by ice and flakes, and sculptures covered by wet made cold and white. This white is not one of absence but of caution. Nature is imperiled, but it is never to be doubted.

Notes

Harold Rosenberg, "The American Action Painters," *Art News* (December 1952)

William Wright, "An Interview with Jackson Pollock," in Francis V. O'Connor, *Jackson Pollock* (New York: Museum of Modern Art, 1967)

1 Hilton Kramer, "David Smith: Stencils for Sculpture," *Art in America* 50 (winter 1962), pp 41–42

2 Katherine Kuh, *The Artist's Voice: Talks with Seventeen Modern Artists* (New York: Da Capo Press, 2000), p. 222

3 United States Atomic Energy Commission, *In the Matter of J. Robert Oppenheimer, Transcript of Hearing Before Personnel Security Board, Washington, D.C., April 12, 1954, through May 6, 1954* (Washington, D.C.: U.S. Government Printing Office, 1954), p. 81

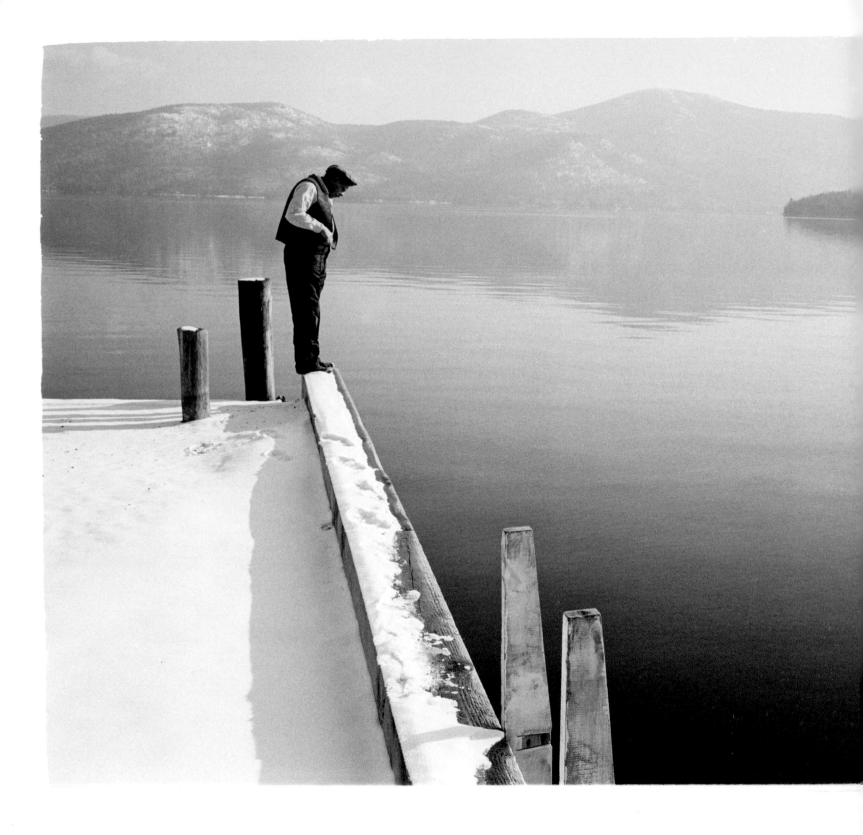

Smith at Lake George, New York, 1962. Photograph by Dan Budnik

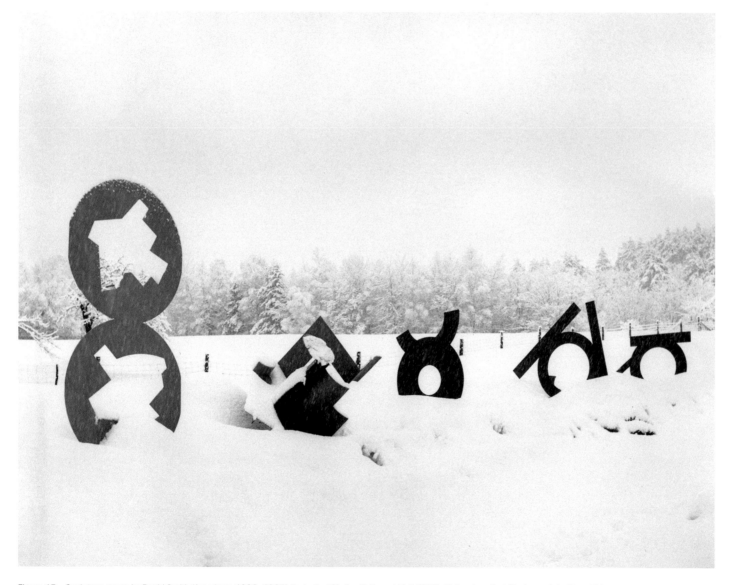

Figure 15 Sculpture group by David Smith (American, 1906–1965), including *Circles III, II,* and *I* (all 1962), Bolton Landing. Photograph by the artist

There Is No Color in the Great Outdoors

Charles Ray

I have never been to Bolton Landing, but as long as I have known of the work of David Smith I have been aware that this is where he made his sculptures. It's not just a location but also a place with a temporal dimension. You can drive from New York City to Lake George and find the town of Bolton Landing. From there, make your way to Edgecomb Pond Road, and the location of the studio and house will be apparent. This is due to memories of numerous photos taken by Smith of his sculptures in the surrounding fields (fig. 15). But what we want from Bolton Landing won't be there. The house and studio and a few sculptures may still be present, but the artist is long gone and the life events that centered on the creation of these sculptures have receded into the past. Still, I would like to go there to think and meditate on Bolton Landing as an important place and time in the history of modern sculpture.

The desire to visit comes not just from appreciation of this artist's work, but also from the nature of the photographs I have seen of him in his studio and of sculptures he placed in the fields of his rural property. The photographs are aging; the character of the people and equipment—even the pictorial nature of the pictures themselves—has all faded into a bygone era. During a lecture on sculpture I presented, I showed several well-known images of Smith's sculptures placed in the upper and lower fields surrounding his studio and home. A colleague in the audience commented that I cheated by showing photos of Bolton Landing in the snow. I was polite. I didn't care about the sting the comment brought. The reduction of sculptural complexity to graphic imagery is an affectation of high-contrast photography from the era of the works' creation. The romantic quality of this photographic effect is obvious, and my own memories are full of similar tricks. Affection for my life has allowed me to see this

imagistic effect as a mental necessity. This beautiful gestalt, if not fully true to what the work was, breaks down the parts of figure-ground with flat scrap metal in the late industrial age. The white ground and stark winter landscape bring a primal quality to the images of *Tanktotems, Cubis,* and other sculptural constructions standing in formation in the fields. They feel simultaneously modern and ancient in their connection to society and ourselves. Is this a reading of the photograph or of how the sculptures really are? Looking at these pictures of sculptures in the snow, I sense the cold hard steel and the brittleness of frozen ground. Yet if you want to truly understand a sculpture like *Zig IV,* pound on it with a closed fist when the museum's guard leaves the room. It's made of steel. It reverberates and is indestructible to your hand or hammer. In a very real sense you have to be in the presence of the thing. You cannot hear it or see it in a photograph.

But where and what is this location where one must be? Is it at Bolton Landing in the presence of Smith's sculptural constructions? That time has passed for the artist and his property. The past is in memory, and sculpture in the real world moves through time differently than sculpture perceived in the mind. While the photographs are fading, these sculptures from a different time acquire fresh cultural color and continue to be seen in a different light with each change in the time of day, month, year, and decade. The origins of their creation are perhaps less important than we would like. The photos of Smith's workplace are romantic and bring on nostalgia for a place I have never visited (fig. 16). These pictures are a visual record and can be interesting and useful for simpler reasons than the ones I mention. If you know how and where a sculpture was made, you have a means to understand an aspect of the work that is often missed in its viewing. This glimpse into a

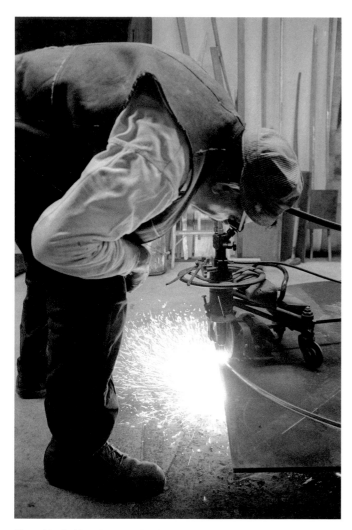

Figure 16 Smith cutting out a circle from sheet steel for *Primo Piano III,* December 1962. Photograph by Dan Budnik

sculpture's history helps us understand the object by stepping back from its obvious function.

Today we have no idea how the ancient Greeks viewed sculpture, but we know how their sculptures were made. The ancient carvers used round punches rather than flat chisels. This is important when you realize the punch must hit the stone at a 90-degree angle, while a flat chisel hits and glances off the stone at an oblique angle. Working with punches shatters the crystalline structure of the marble, but the flat chisel removes material by shaving off the surface, preserving the stone's molecular structure. The use of punches necessitates working completely in the round. A carver must pass all the way around a block, peeling it like an onion, before changing down to a smaller-size punch. Detail is refined as the punch sizes are reduced. This is why in a kouros figure there is a great democracy of events across the surface of the sculpture. Details slowly emerge across and around the entire stone: a hand is equal to a knee, a lip to a toe, and even a fingernail to an eye. All elements of the figure emerge equally together, at the pace dictated by the method of carving. Renaissance sculptors used flat chisels, and shaving and reducing areas of stone allowed an entire face to emerge while the rest of the block was simply roughed out. One cannot separate mind and vision from method and technique. Classicist Richard Neer explains why the block of stone is important to a kouros figure. The quarry is its place of origin, and these beautiful archaic figures bring the quarry with them, stepping forward in time as smooth objects in a rough and textured world. Smith put his work in the landscape, using it as a tool in the making of his sculptures: Bolton Landing was a chisel.

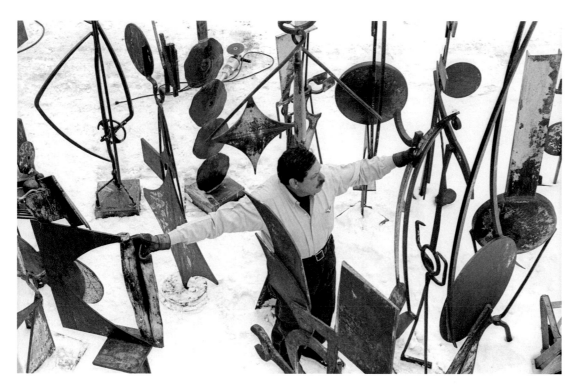

Figure 17 Smith with some
of his sculptures, c. 1962–64.
Photograph by Dan Budnik

The critic Peter Schjeldahl once commented to me that Bolton Landing was a cocktail party (fig. 17). This cartoonish image brings another quality of the work to our attention. I think of a wedding reception for two families—the *Tanktotems* and the *Cubis*—as they stand around the fields and pond of Bolton Landing on a summer afternoon. This image takes hold due to the totemic quality of Smith's abstract sculptures, which are modern and ancient simultaneously. The vertical organization of Smith's work begins or ends on the ground. The sculptures stand upright, creating an awareness that we are in the presence of work that, although made today, shares with ancient figuration our common relationship to the past.

There is, I think, a human attempt to carve meaning or narrative out of the pure sculptural and expressive power of Smith's constructivist sculptures. Aerial photographs of his property at Bolton Landing reveal a reality of intent that is not domesticated by a plastic relationship to the pictorial setting of a rural neighborhood (fig. 18). Studio, house, fields, fence, flowers, and trees, seen from the sky, show the path of a river of expression flowing out of the studio into the surrounding fields.

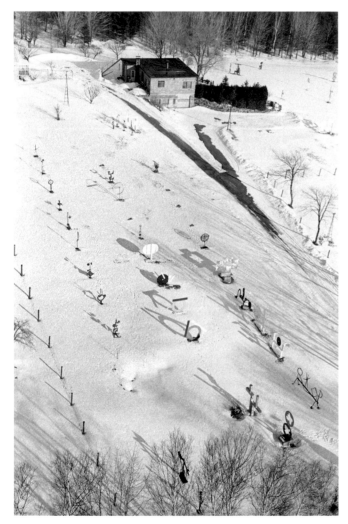

Figure 18 North Field at Bolton Landing, c. 1967. Photograph by Dan Budnik

Smith called this momentum of sculptures his "work stream." His daughter Candida used these photographs to illustrate an exhibition essay for a show at Storm King, *The Fields of David Smith.* In this same catalogue Anthony Caro is quoted: "Smith must have been lonely up there; Moore put his work out in the landscape to show the world that he was great, but Smith did it to show himself that he was great."[1]

What we see in others is often true, even when it reflects oneself, and I think both Smith and his work can be understood partly through their relationship to what we often refer to as the "great outdoors." The outdoors is something outside our door. It is where we go sledding, horseback riding, hunting, gardening, and swimming. The great outdoors, however, is so far out it is found back inside, and comes forth in an expressive flow. Perhaps the great outdoors is where no difference remains between what is external and internal. Smith used the landscape to produce his sculptures—not as a vessel in which to place or arrange them. His river of expression, his work stream, had a strong momentum, and this expressive force comes with erosive power that can carve thoughts as a river carves the landscape or as chisel or punch in an artist's hand shapes a block of stone. The landscape of Bolton Landing was not an exhibition space but a template, vise, wrench, or workbench. Nor was it just a place where this artist worked. Bolton Landing was the landscape that, through sculptural thought, brought a unique vision of spatiality to Smith's construction (fig. 19).

Constructivism brought the tradesman's methods to the studio. The artist-welder abandoned the idea of additive and reductive techniques, such as carving wood and stone, or building on an armature with clay. Modeling and shaping form into an orchestrated whole was abandoned in favor of building

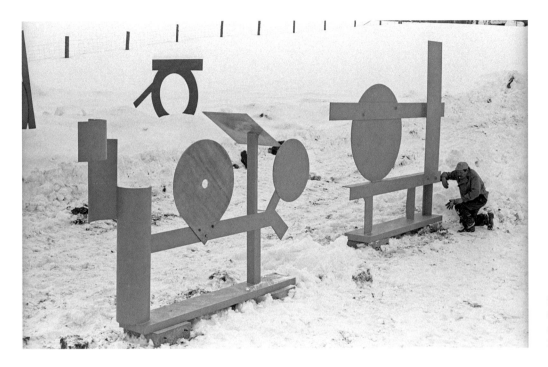

in space and developing a philosophical eye for a relationship
of parts. Space is brought into this equation in an active way.
It is no longer what material the sculptor builds *in,* but what
he or she builds *with.* We grasp at meaning where there is
none. Constructivism in the early twentieth century freed line
drawn on surface by extending linearity into space, causing a
singularity in art. Cubism in painting is a radical approach to
pictorial structure. In sculpture it is a reinvention of art itself.
Meaning is not depicted as much as it is generated.

I think we tend to stay with familiar terminology when looking
at unfamiliar things. We need what is identifiable not just in contour
but also in the events with which the unfamiliar is engaging. Once

Pablo Picasso and Julio González extended the steel line out into
our space, as line became the medium of the sculptor, space lost
its neutrality. Space as a container or empty field is lost forever.
Albert Einstein's equations tie space to time, and we learn that
force is the shape and form of space. If we don't understand the
math, we look at modernist sculpture to understand how we are *of*
the world rather than *in* the world. Containers lose their meaning,
if not their function. A steel line drawn in space is not a bridge for
pedestrians, cars, or trains (fig. 20).

Smith's work is awake to the location of its creation. Through
the elements of the local landscape—a line of trees, a mountain,
sloping fields, a pond—a sculpture such as *Australia* has less literal

reference to the Adirondacks than to elements of landscape. Steel bars and end cuts and other industrial scrap magically become like clay. Each element is extruded through Smith's hand, yet simultaneously forged by industry. The work acquires energy from the sculptural thought and touch of the artist's intentionality. If the title *Australia* refers to the springy kangaroo emerging from

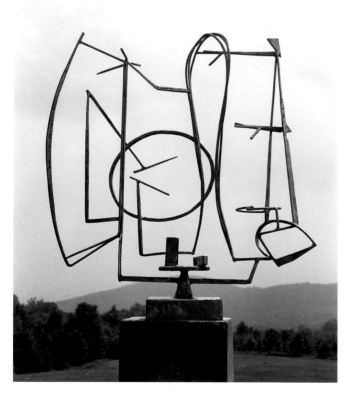

Figure 20 David Smith, *Stainless Window*, 1951, Bolton Landing. Stainless steel, 31½ × 27 × 6 in. (80 × 68.6 × 15.2 cm). The Estate of David Smith. Photograph by the artist

elements of the sculpture, this pictorial quality is a starting point for a sculpture of real scale born out of the real space around Smith's studio. Yet, it does not refer to anything else. The sculpture is not Australia. The elements referring to a kangaroo are important poetically as an abstract spring or the life or heartbeat of a world. Landscape is abstract. Smith's sculpture is an armature for space, not clay. Turn the sculpture, and the world turns with it. The sculpture is no more in the world than a tooth is in your mouth. It is rooted to your jaw like a tree to a meadow. I do not mean this literally, as if the sculptures were site specific. I am saying that the sculptures are qualities of the landscape.

Take your cell phone and throw it at a Henry Moore sculpture. It will sail right through the hole. Throw the same phone at the empty space in the middle of David Smith's *Untitled (Candida)* from 1965 (fig. 21), and it will bounce right off. It can't go through. The empty space is the same size and shape as the staggered plates of this great work, but it is also as solid as the stainless steel plate upon which Smith ground reflective patterns across the surface. Light bounces and is refracted, and the sculpture is held in place by light itself. This sculpture never becomes a frame. A topologist will tell you that a two-dimensional creature is impossible. A digestive tract would cut the poor creature in two. Smith's *Untitled (Candida)* is shallow, but it reverberates and fills the third dimension. The landscape is digested and visible in the internal structure or belly of the sculpture. The sculpture eats and then retains space as a central element of its relational construction. It's a great example of how exterior space and interior space are really one and the same.

We could ask the question, Is the great outdoors outside? The philosopher Quentin Meillassoux sees it as what is here

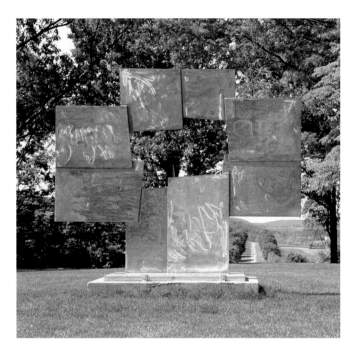

Figure 21 David Smith, *Untitled (Candida)*, 1965. Stainless steel, 103 × 120 × 31 in. (261.6 × 304.8 × 78.7 cm). The Estate of David Smith

when we are not. This brings me to the story of certain sculptures that find a way to remain as objects when other artifacts are long lost or have disintegrated. With time, sculpture sheds its ideas, and what is left is what the artist made. How do certain works enter time while others die when we forget the purposes they originally served?

Whether indoors or outdoors, these works, I think, are found only in the great outdoors. David Smith found a way to allow his work to enter time. As we say, "time will tell," but look at much of Smith's work and it can feel frontal and

especially flat. Looking closer, we see that it is never flat but often so shallow and three-dimensional that perhaps it was compressed—rather than exploded—into being. Your art professor may have told you that Smith's early works relate to painting of the time. The historian and critic Michael Fried once told me that Smith's sculptures are great, despite their painted surfaces. I think he meant that the sculptures were so strong that even the painted surfaces affecting abstract painting of the time could not hold the works back. Painted inside the studio, the sculptures step outside and enter the great outdoors.

I do not mean to sound negative concerning the painted surfaces of David Smith's sculpture. As an artist-viewer, I like and learn from Smith's use of color. I do not see it as secondary or applied. Smith brought everything he had to bear on his creation of the sculptures. The painted surfaces of ancient Greek sculpture, while not lost to us in fact, have lost the relation to the aesthetic of the work as we perceive it today. Similarly, the age worked through Smith, and you can notice the decades shift as his color shifts from abstract expression to the more solid colors of pop. Smith launched his sculptures into the stream of time, and as they float away from our critical control, new relations among the viewers, the sculptures, and the world continue to engage. The form of archaic sculpture as well as the work of David Smith carries the figure of the man, and color is left to claim itself only as a fact.

Note

1 Candida N. Smith, *The Fields of David Smith* (New York: Thames and Hudson, 1999), p. 54

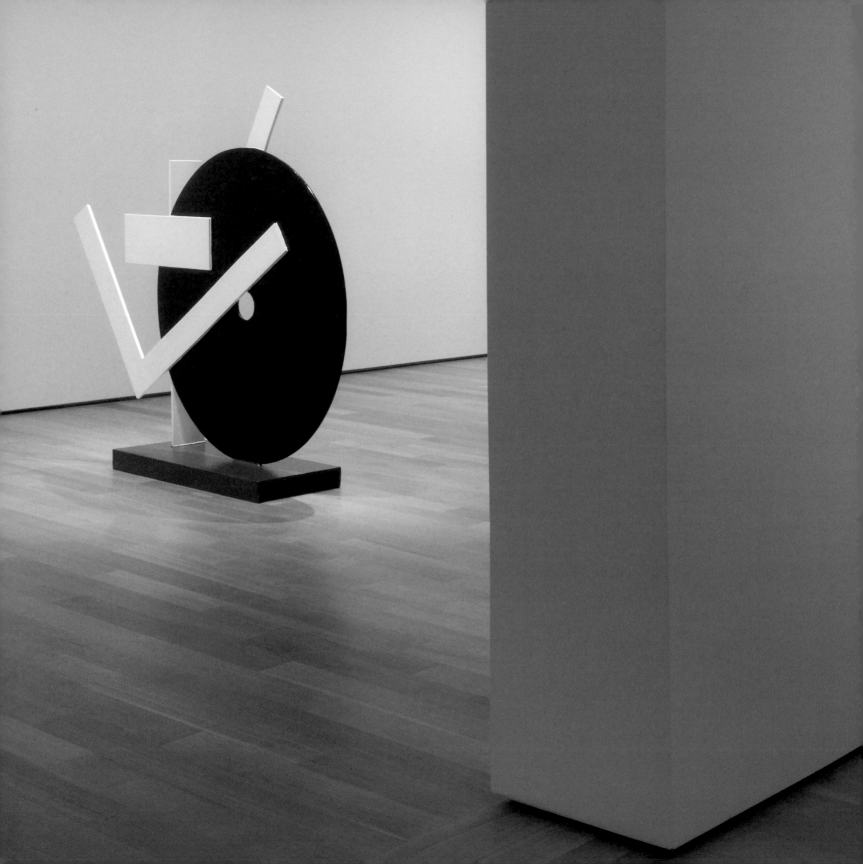

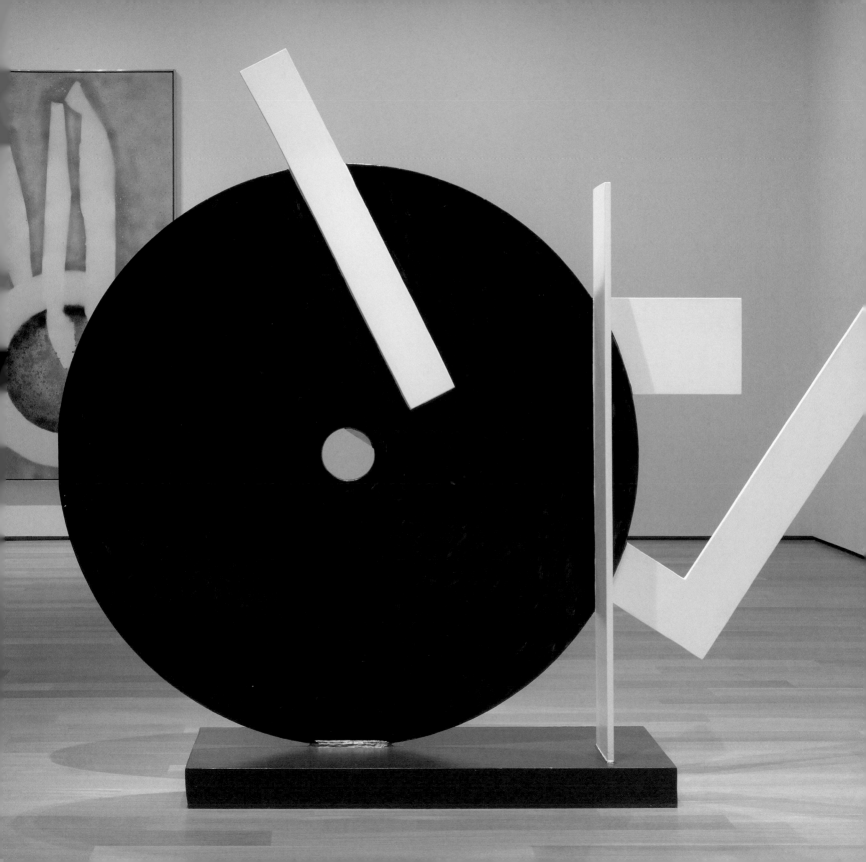

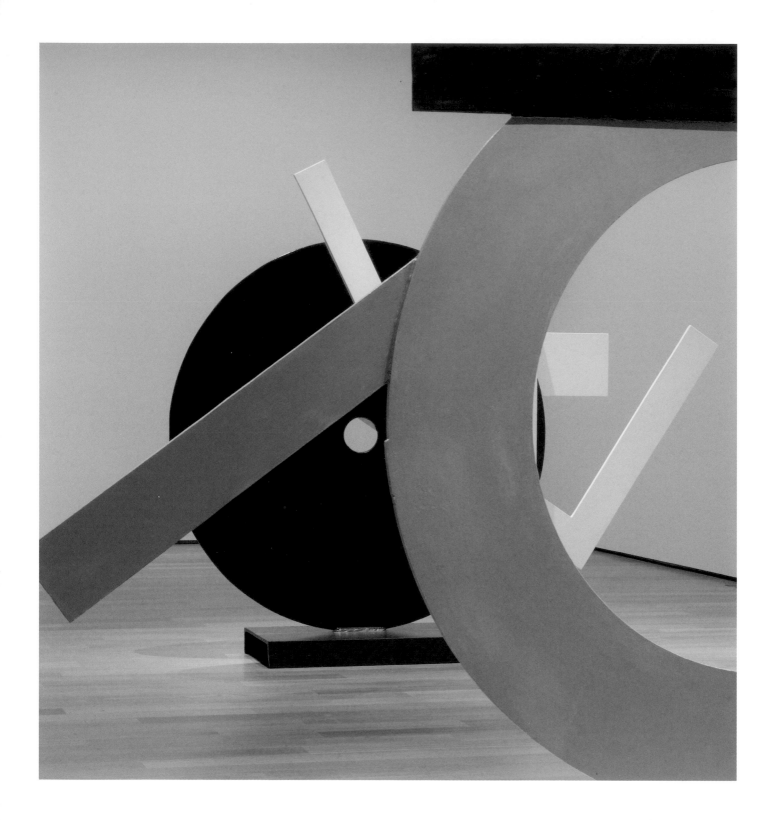

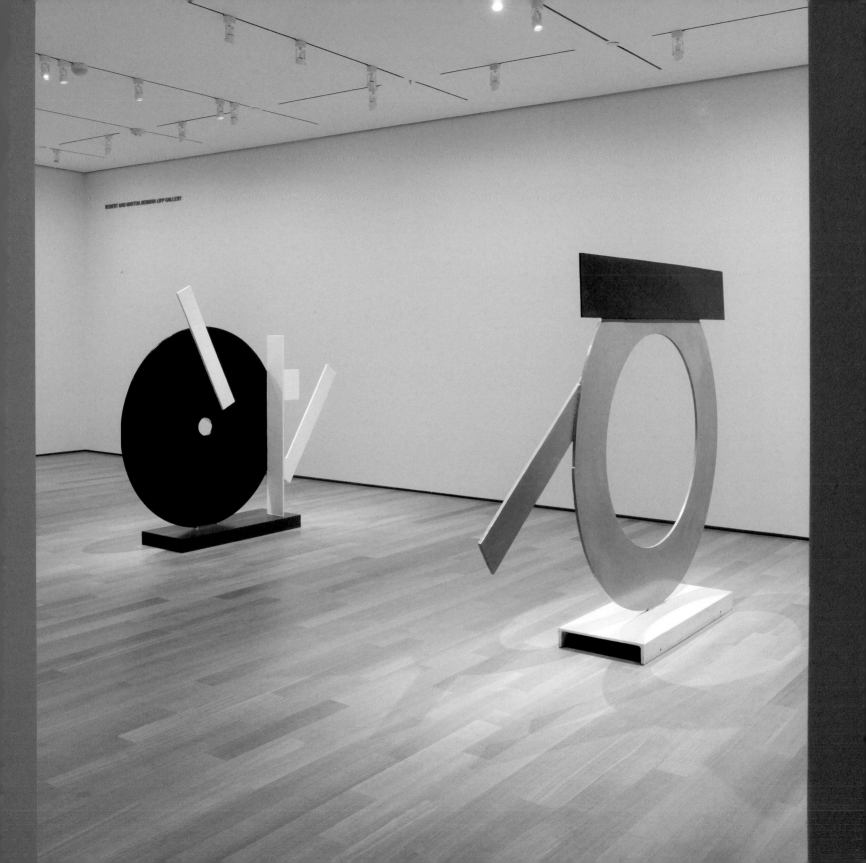

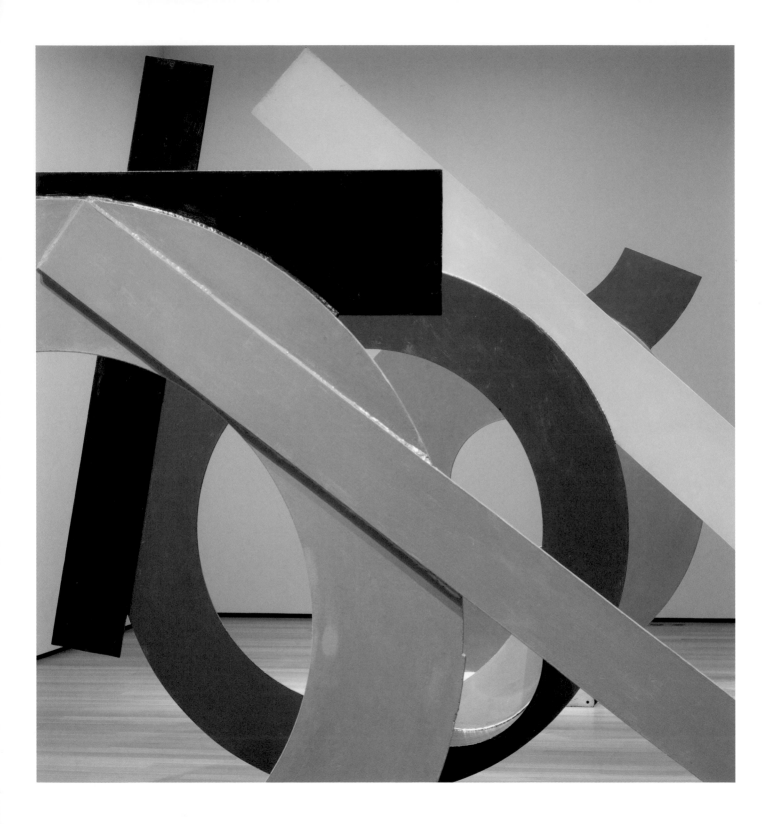

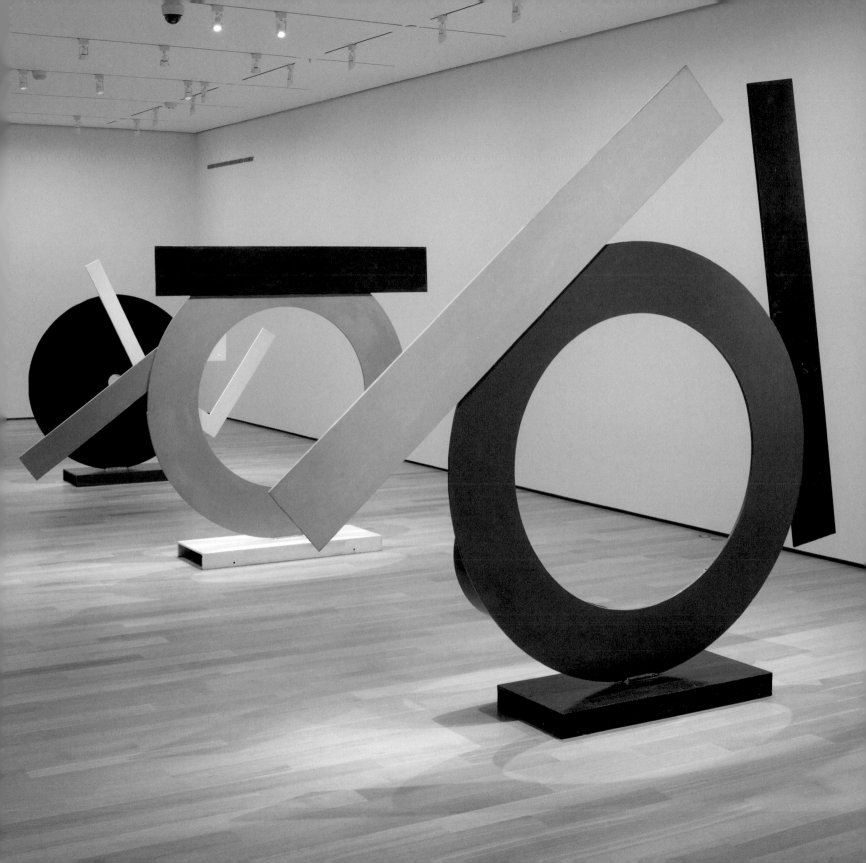

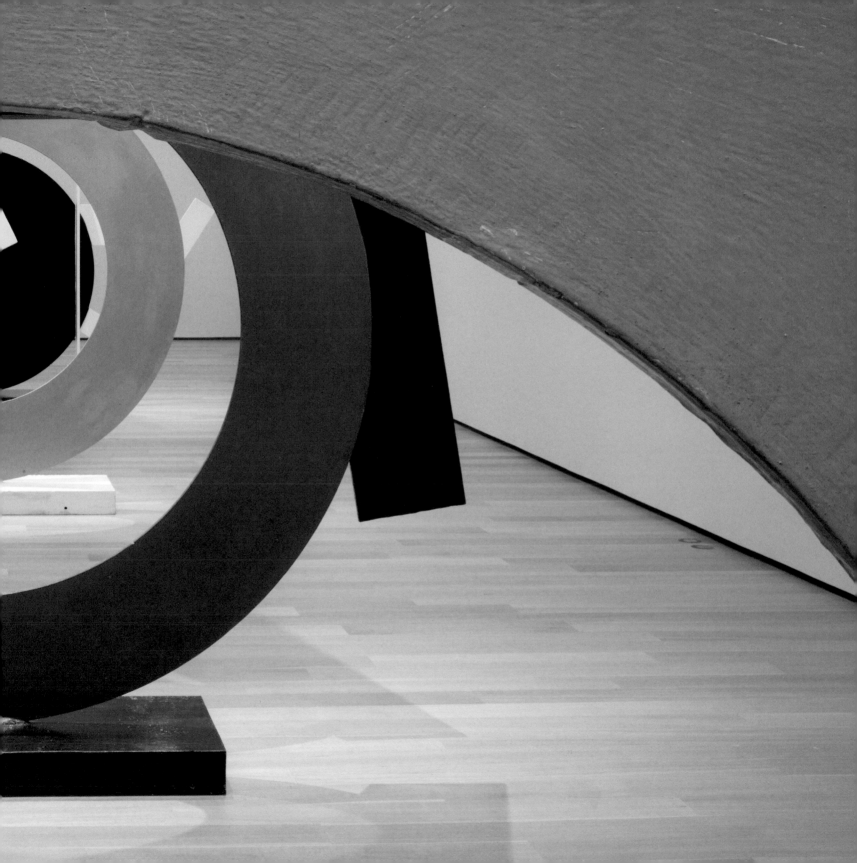

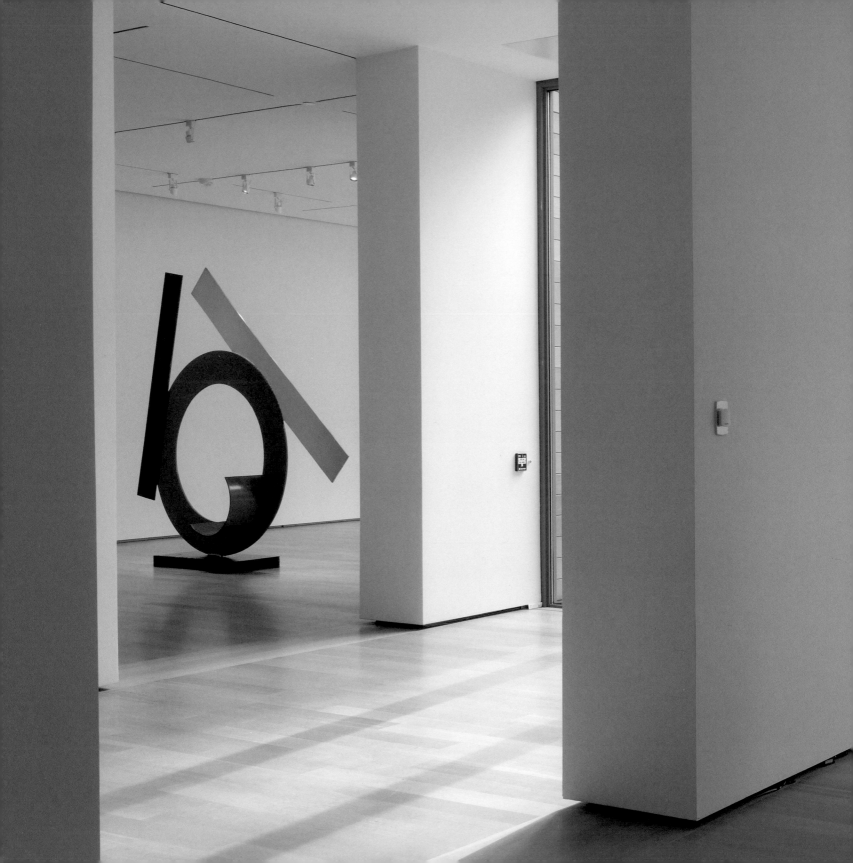

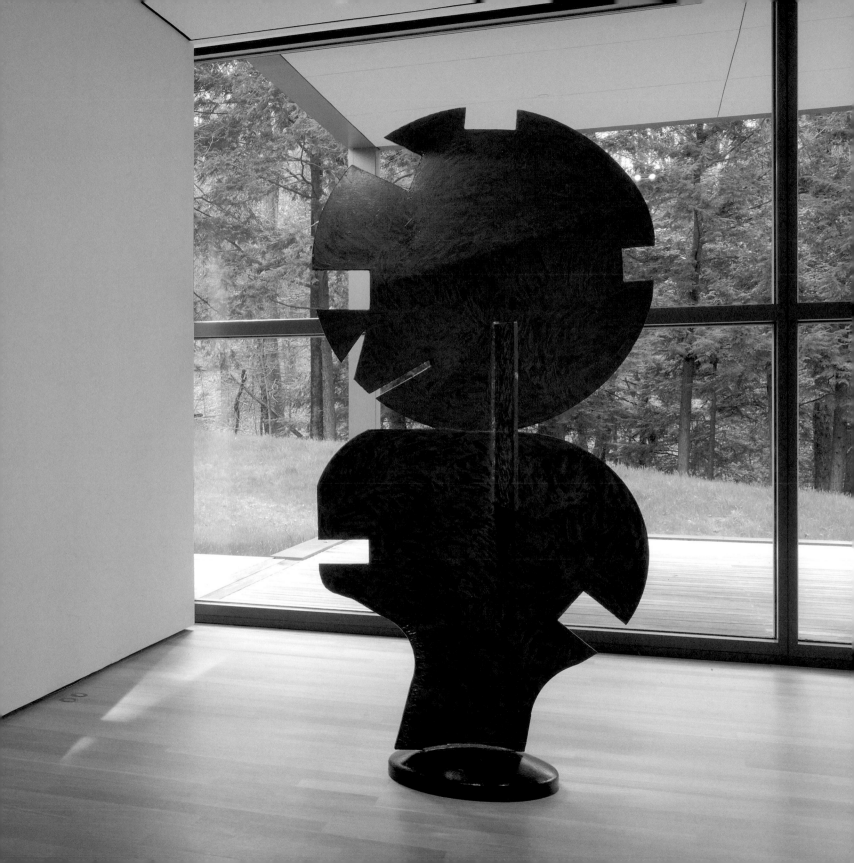

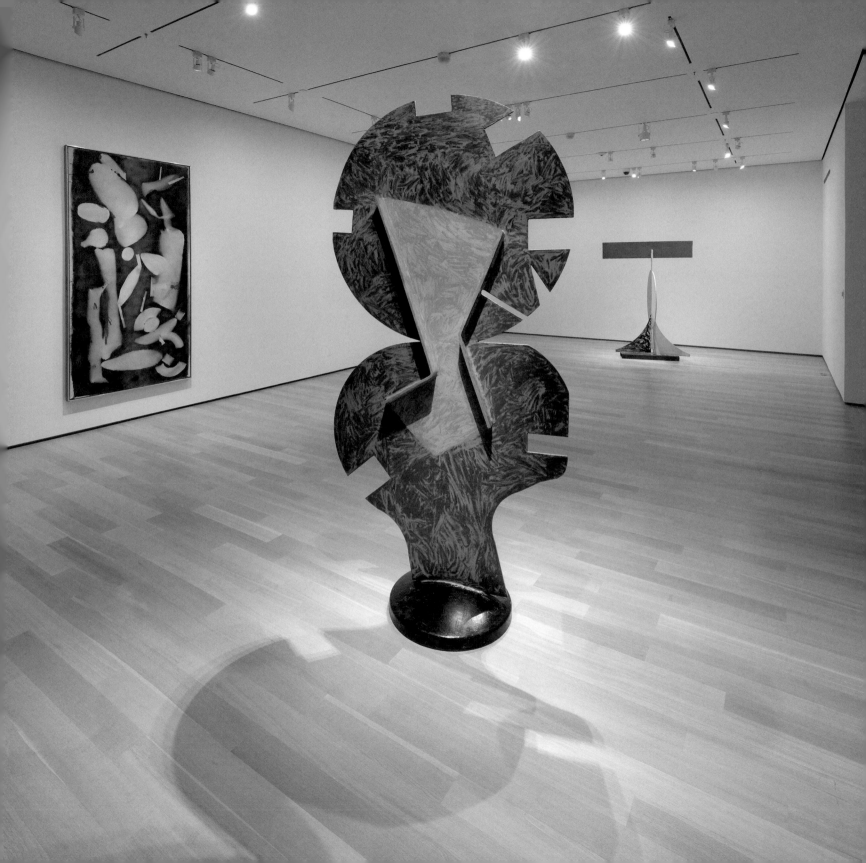

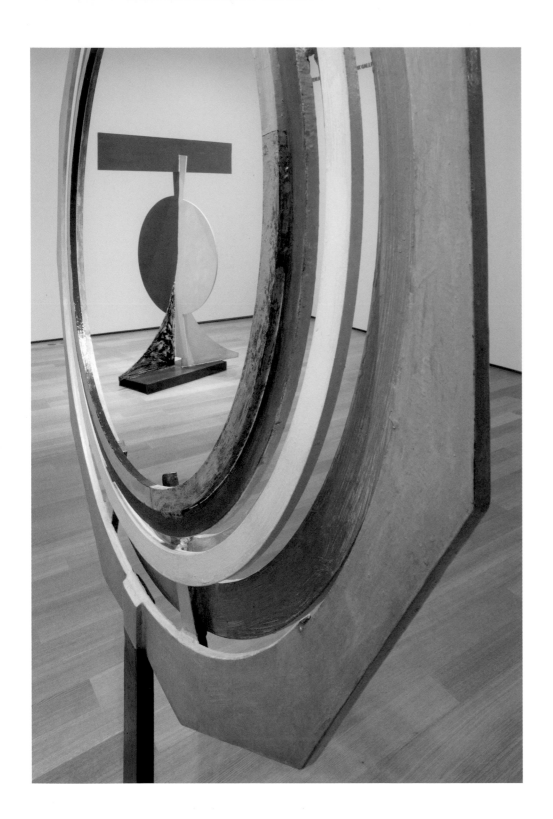

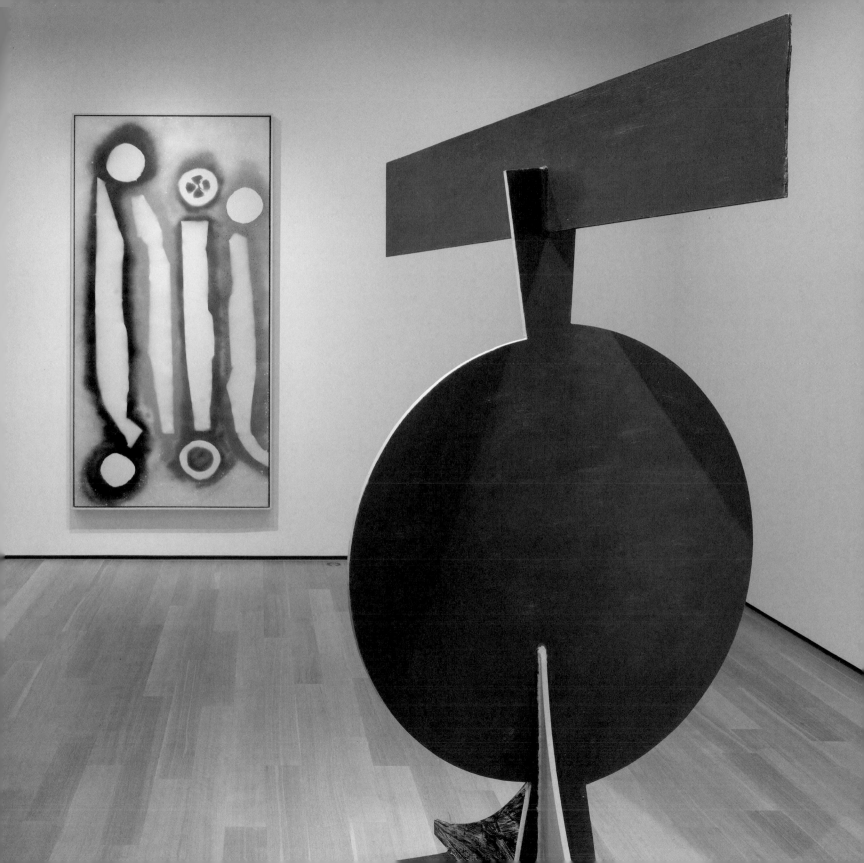

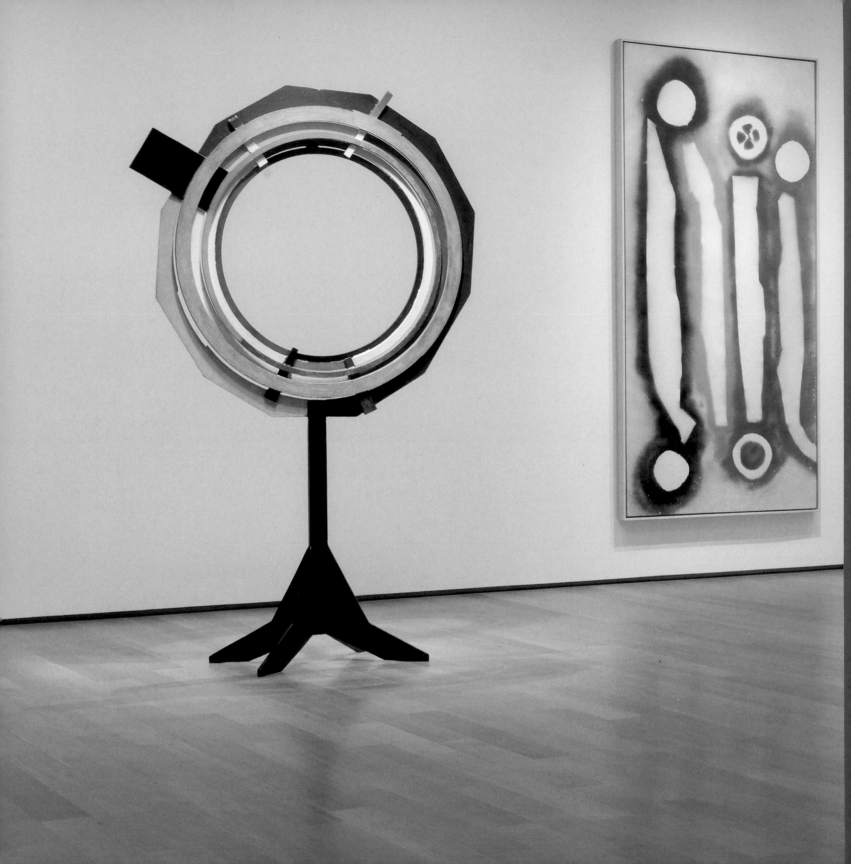

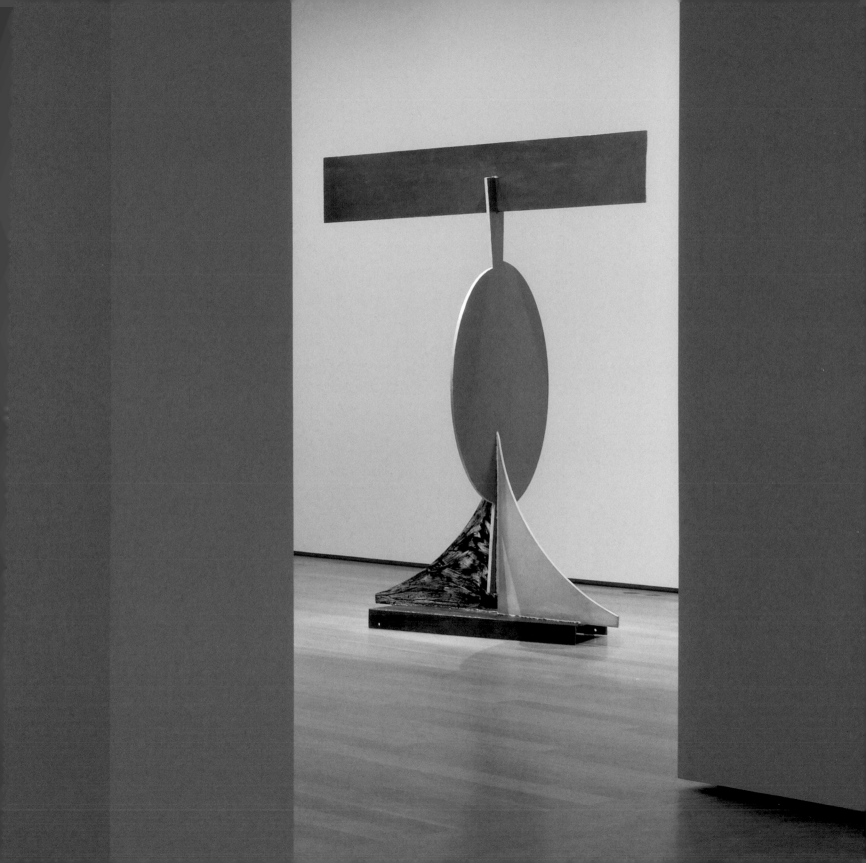

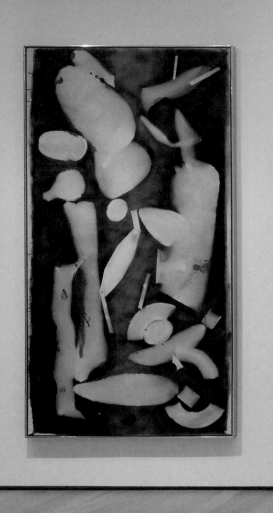

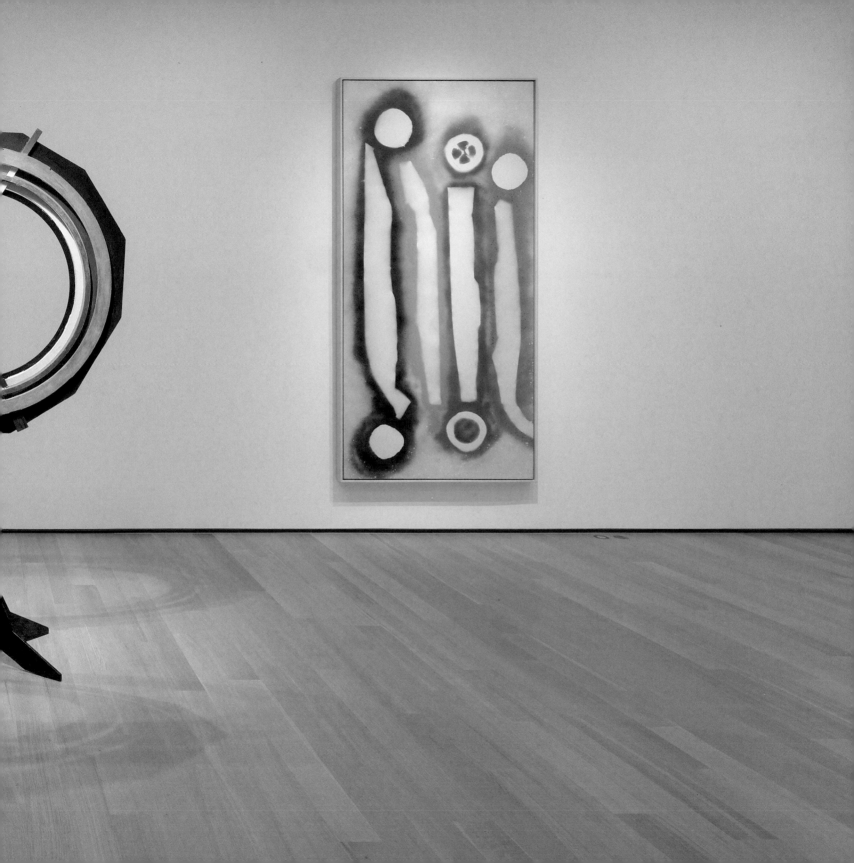

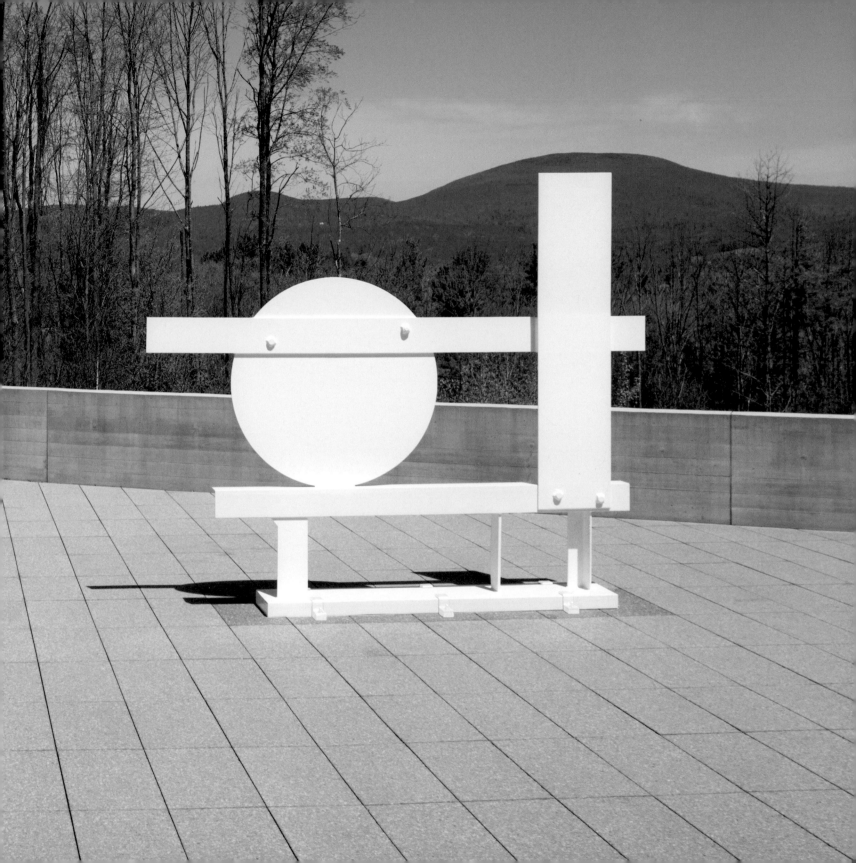

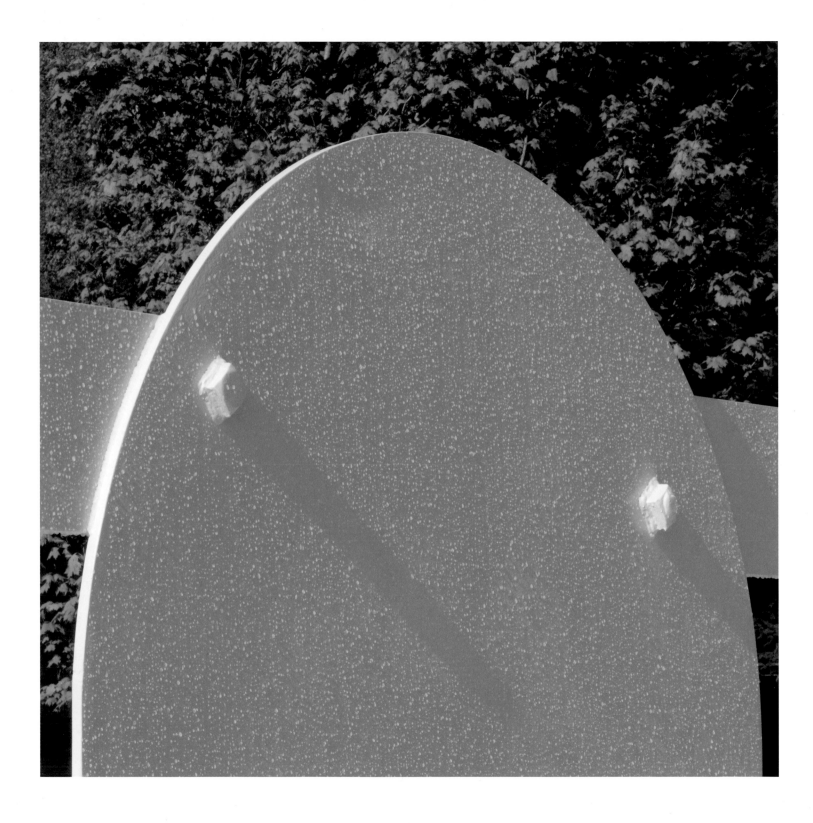

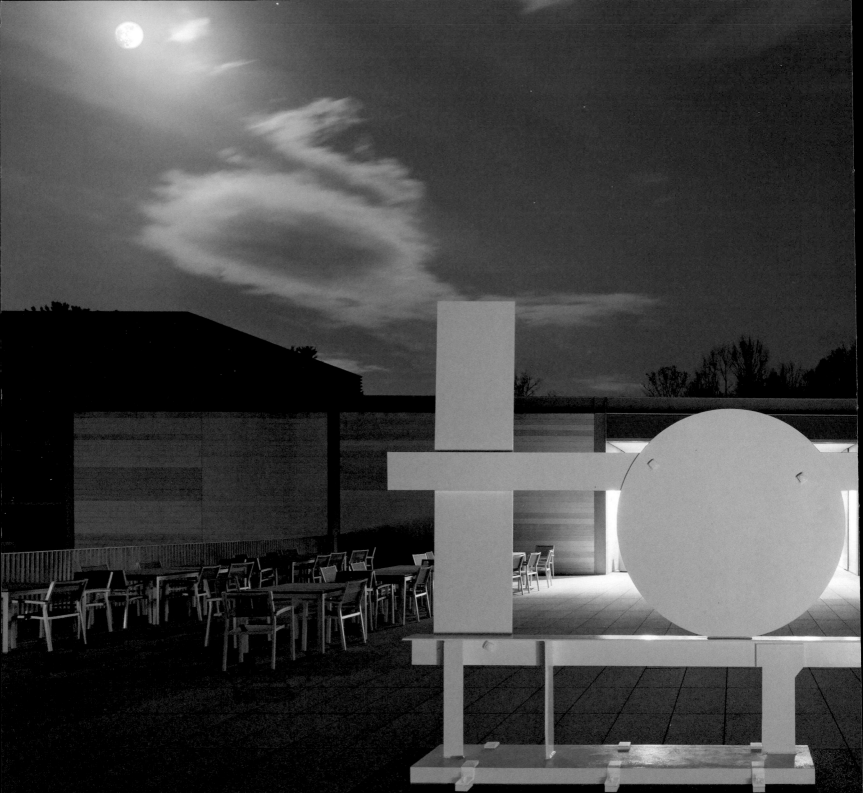

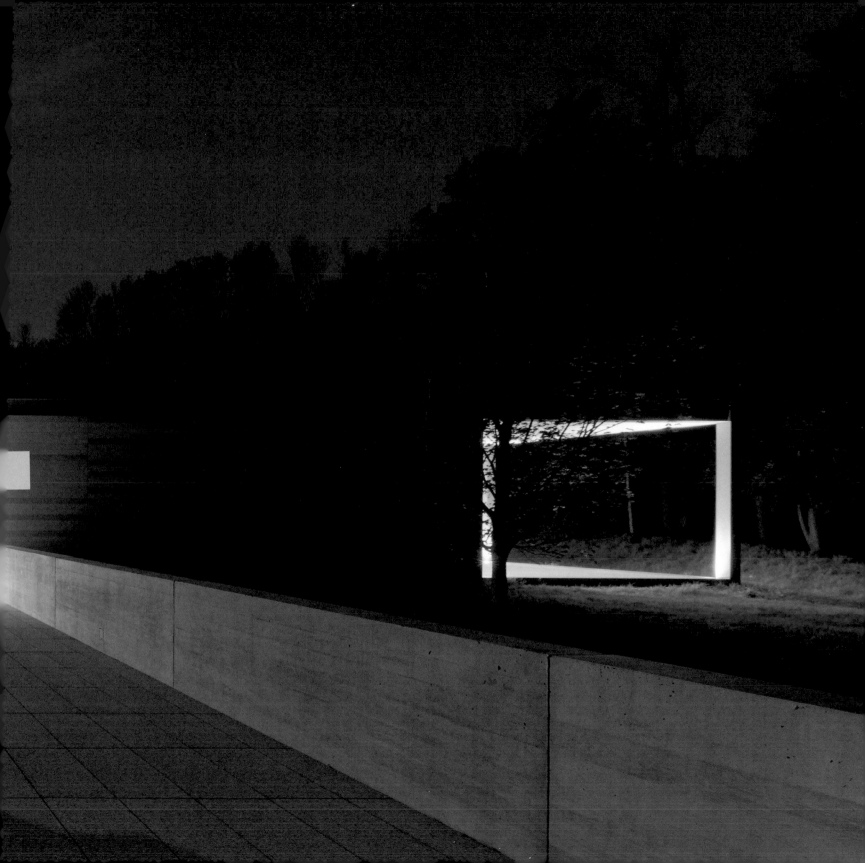

Checklist

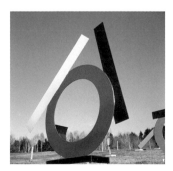

1
Circle V, 1963
Painted steel, 77 × 90 × 20 in. (195.6 × 228.6 × 50.8 cm)
JPMorgan Chase Art Collection

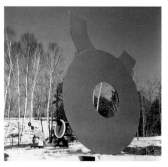

2
Circle I, 1962
Painted steel, 79 × 107 ¹¹⁄₁₆ × 18 in. (200.7 × 273.5 × 45.7 cm)
National Gallery of Art, Washington, D.C. Ailsa Mellon Bruce Fund,
1977.60.1

3
Circle II, 1962
Painted steel, 105 ½ × 110 ¹¹⁄₁₆ × 23 ⅝ in. (268 × 281.1 × 60 cm)
National Gallery of Art, Washington, D.C. Ailsa Mellon Bruce Fund,
1977.60.2

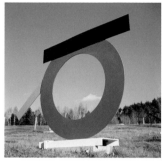

4
Circle III, 1962
Painted steel, 95 ½ × 71 ¹⁵⁄₁₆ × 18 in. (242.6 × 182.7 × 45.7 cm)
National Gallery of Art, Washington, D.C. Ailsa Mellon Bruce Fund,
1977.60.3

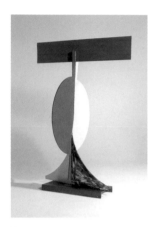

5
Circle IV, 1962
Painted steel, 85 × 59 ¾ × 15 in. (215.9 × 151.8 × 38.1 cm)
The Estate of David Smith

6
Circles Intercepted, 1961
Painted steel, 89 ½ × 56 × 20 in. (227.3 × 142.2 × 50.8 cm)
The Estate of David Smith

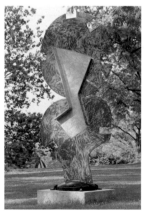

7
Dida's Circle on a Fungus, 1961
Painted steel, 100 × 47 × 16 in. (254 × 119.4 × 40.6 cm)
The Estate of David Smith

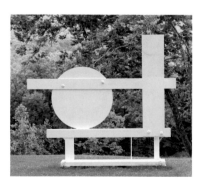

8
Primo Piano III, 1962
Painted steel, 124 × 146 × 19 in. (314.9 × 370.8 × 48.3 cm)
The Estate of David Smith

9

Untitled, 1962

Spray enamel on canvas, 95 × 48 in. (241.3 × 121.9 cm)

Collection Albright-Knox Art Gallery Buffalo, New York. Pending
Acquisition Funds, 2014

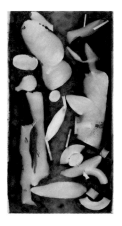

10

First Ovals, 1958

Spray enamel on canvas, 98 ½ × 51 ¾ in. (250.2 × 131.4 cm)

Private Collection, Courtesy Gagosian Gallery

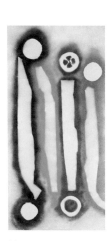

11

Untitled, 1959

Spray enamel on canvas, 101 × 48 ½ in. (256.6 × 123.2 cm)

The Estate of David Smith

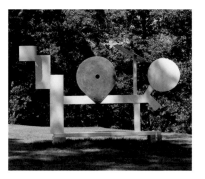

12

Primo Piano II, 1962

Bronze and painted steel

85 × 158 × 15 in. (215.9 × 401.3 × 38.1 cm)

The Estate of David Smith

Photography Credits

Contributors

Michael Brenson is an art critic, art historian, and teacher.

David Breslin is the associate director of the Research and Academic Program and associate curator of contemporary projects at the Clark Art Institute.

Charles Ray is an artist based in Los Angeles.